colour
THERAPY
AN ANTI-STRESS
COLOURING
BOOK

Michael O'Mara Books Limited

Illustrated by Richard Merritt,
Cindy Wilde and Laura-Kate Chapman

Written & edited by Sophie Schrey

Cover design by John Bigwood

Designed by Jack Clucas

With additional material adapted from www.shutterstock.com

First published in Great Britain in 2015 by Michael O'Mara Books Limited,
9 Lion Yard, Tremadoc Road, London SW4 7NQ

W www.mombooks.com
f Michael O'Mara Books
y @OMaraBooks

A CIP catalogue record for this book is available from the British Library.

ISBN: 978-1-78243-325-5

6 8 10 9 7 5

This book was printed in June 2015 by Leo Paper Products Ltd, Heshan Astros Printing Limited,
Xuantan Temple Industrial Zone, Gulao Town, Heshan City, Guangdong Province, China.

Colour is powerful.

From the burnt oranges of autumn to the tranquil blues of a tropical sea, colour can affect mood and evoke strong memories or feelings.

The images in this book are intricate because focusing on detailed tasks can be therapeutic — relaxing and calming a busy mind. There are seven colour sections, each containing a mixture of colouring and doodling. Why not work your way through the spectrum or just dive in?

There is no right or wrong way to use this book, no rules or complicated step-by-step instructions; there are only exquisite pieces of artwork to which you can add your own creativity.

Pick up a pen or pencil and get creating ...

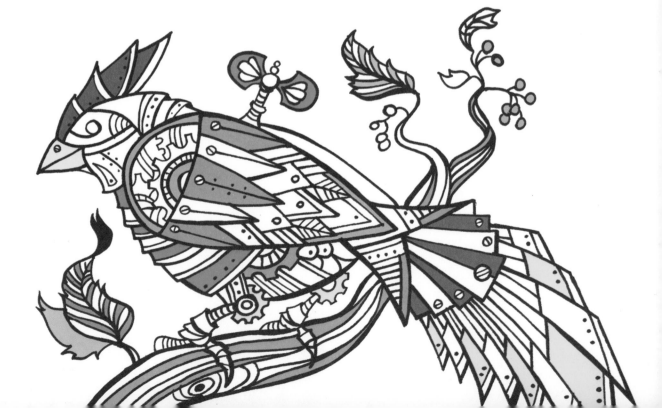

COLOUR WHEEL

COMPLEMENTARY COLOURS

Complementary colours sit opposite each other on the colour wheel. When used side by side they have the strongest contrasts. Use them to create vivid, eye-catching designs.

WARM COLOURS

Oranges, reds and yellows are warm colours, associated with heat and light. They are fiesty and rousing.

COLD COLOURS

Blues, greens and purples are cool colours, associated with sky and water. They are calming and soothing.

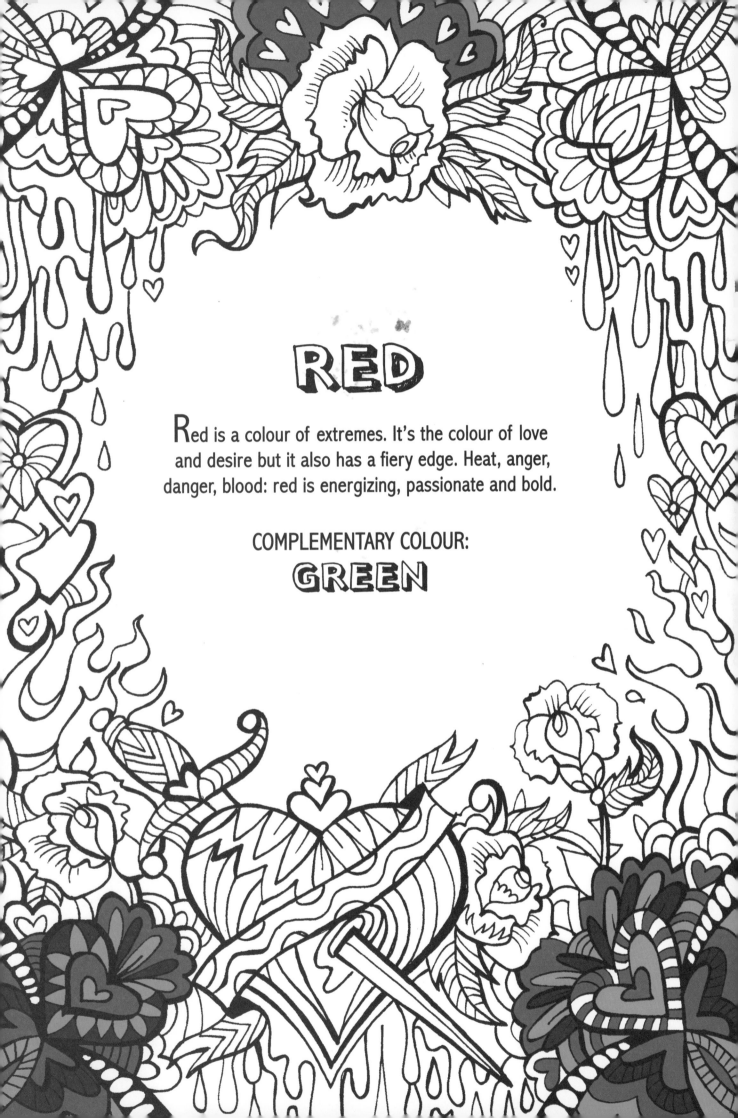

RED

Red is a colour of extremes. It's the colour of love and desire but it also has a fiery edge. Heat, anger, danger, blood: red is energizing, passionate and bold.

COMPLEMENTARY COLOUR:
GREEN

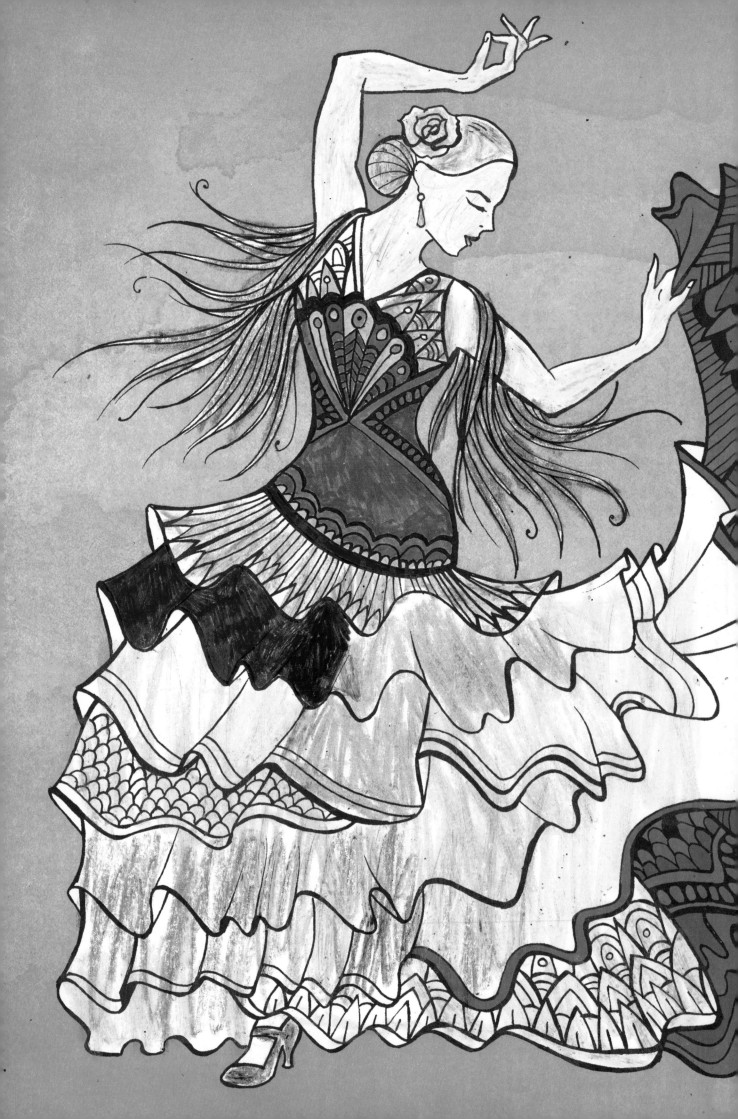

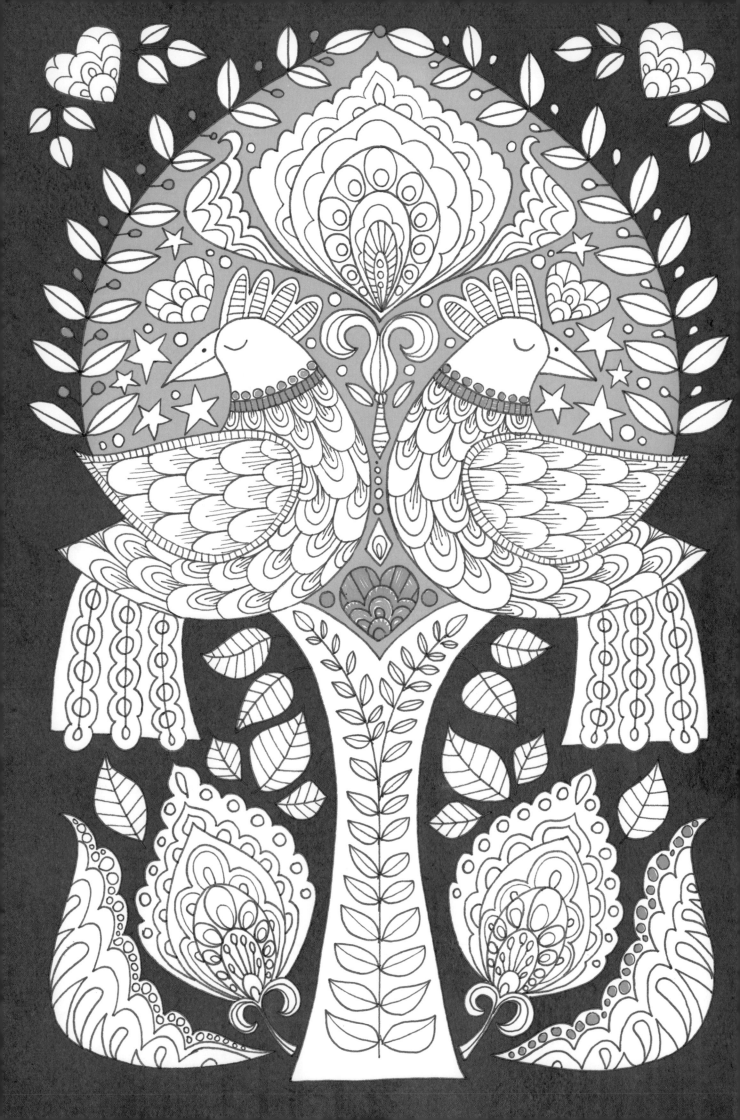

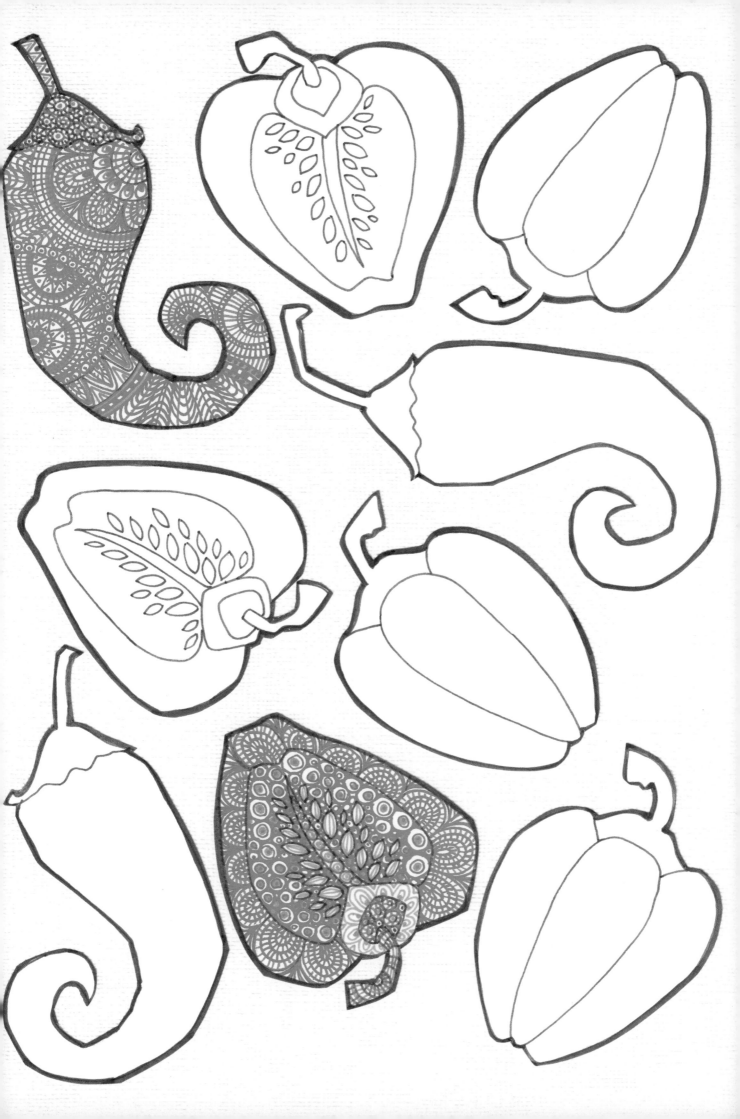

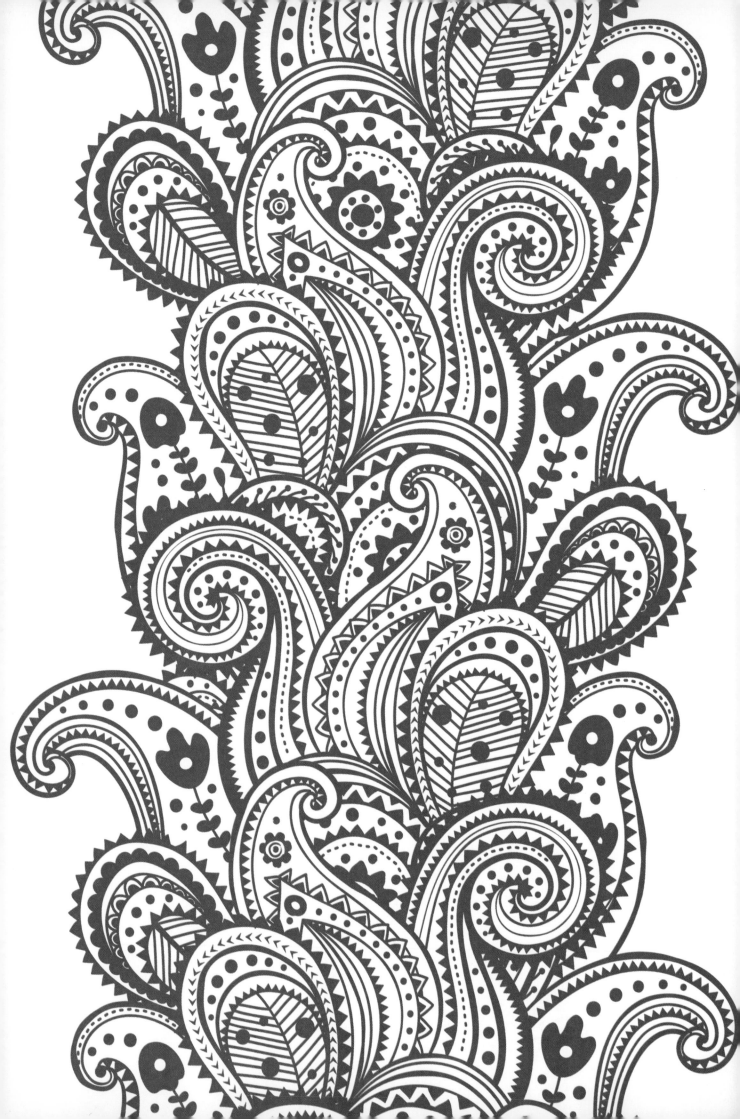

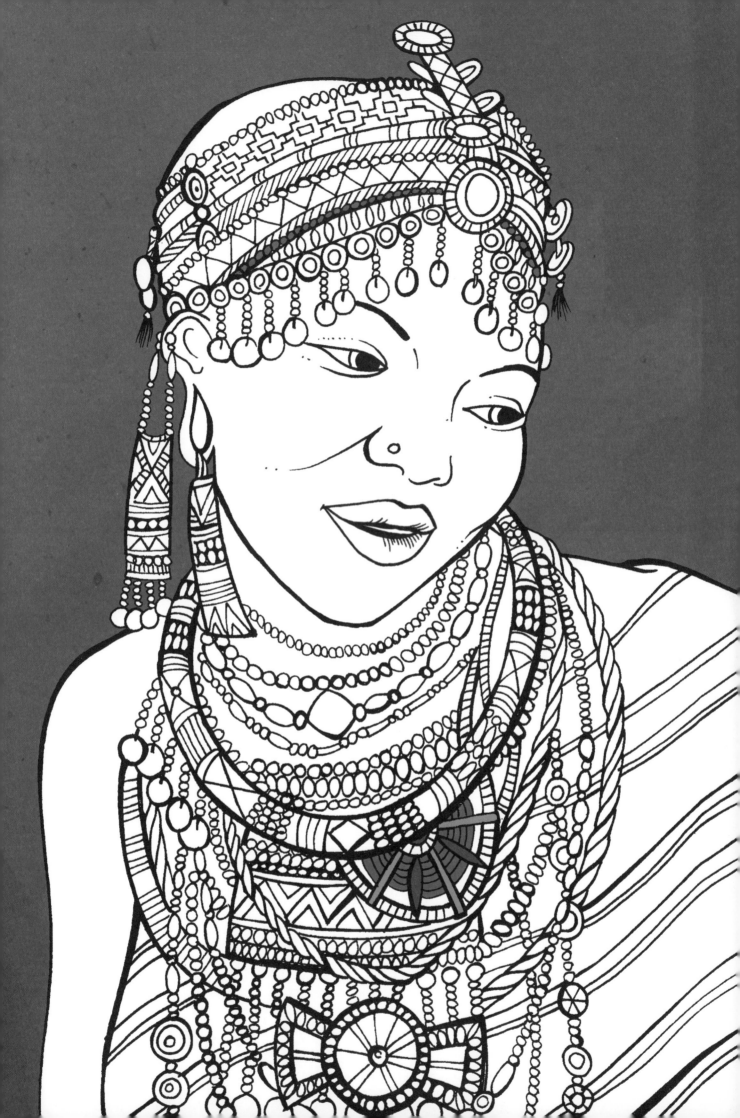

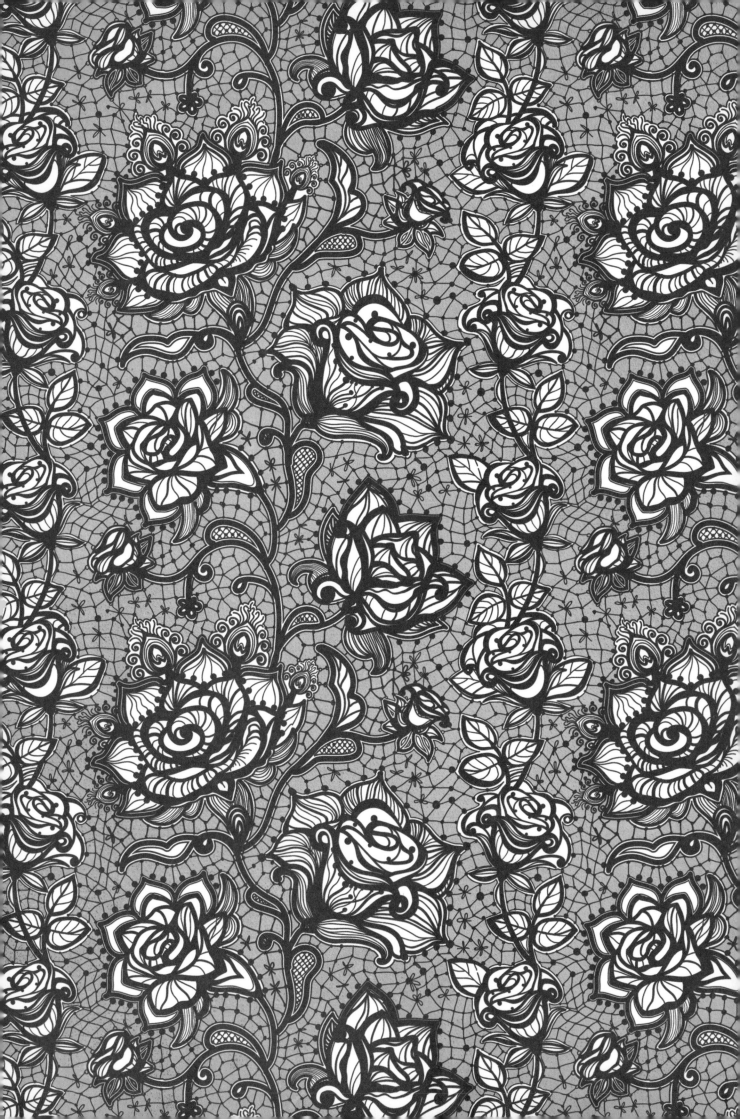

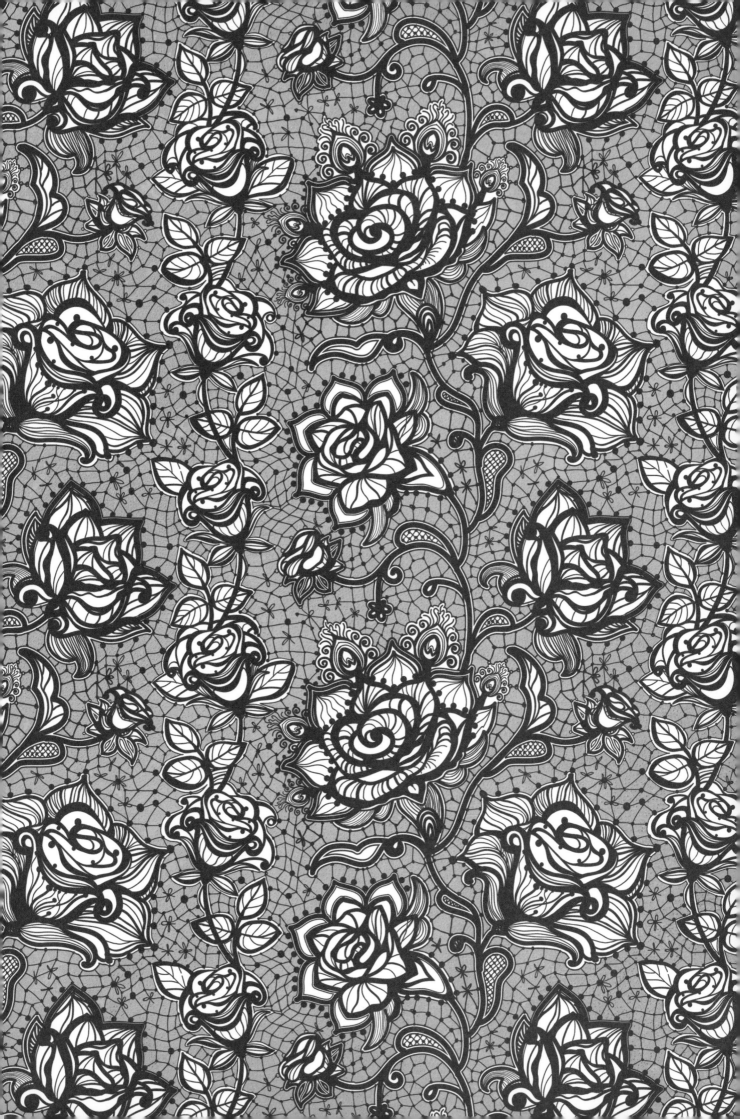

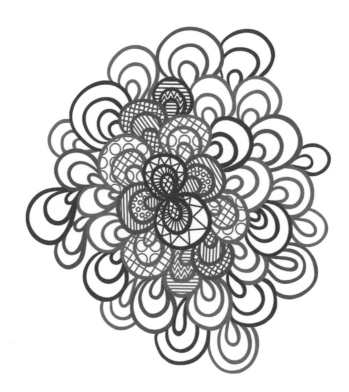

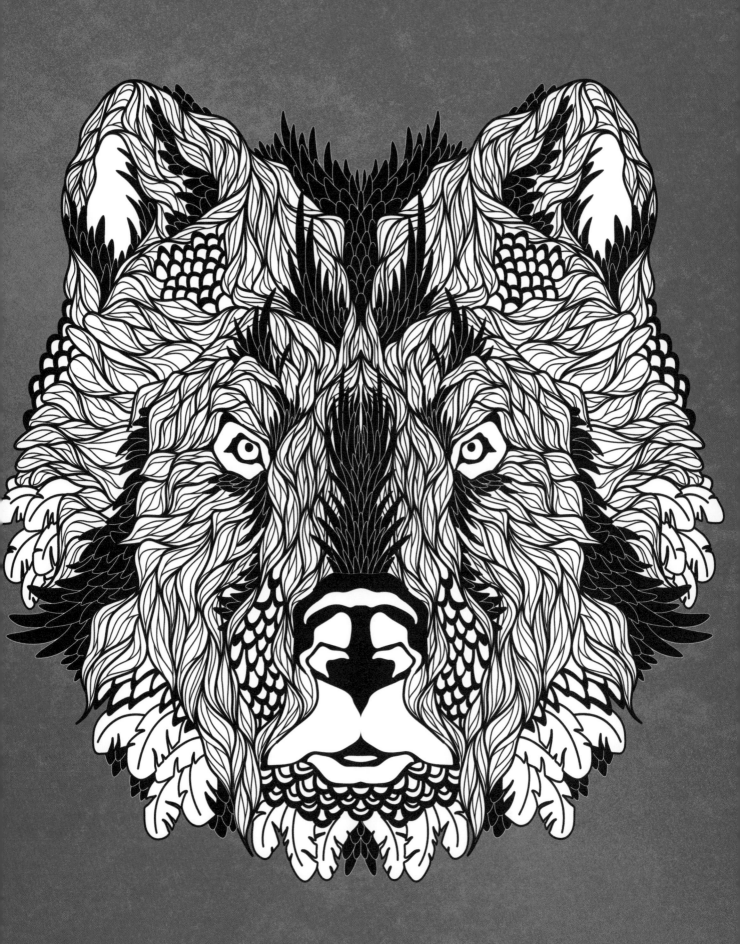

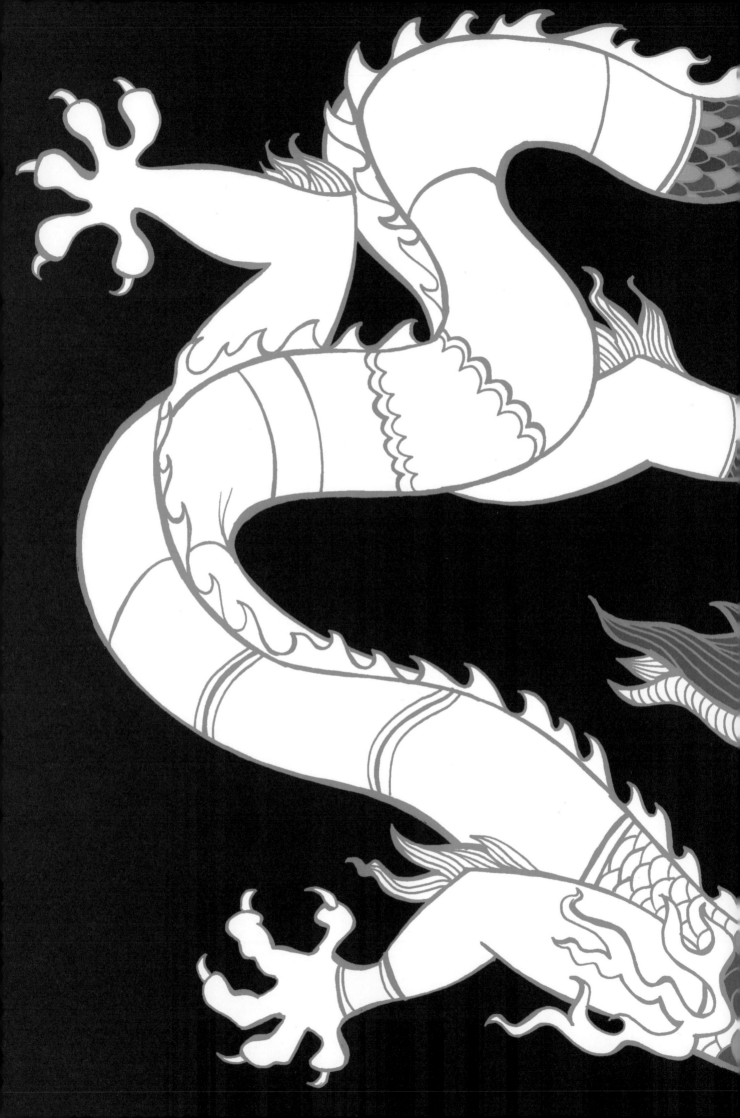

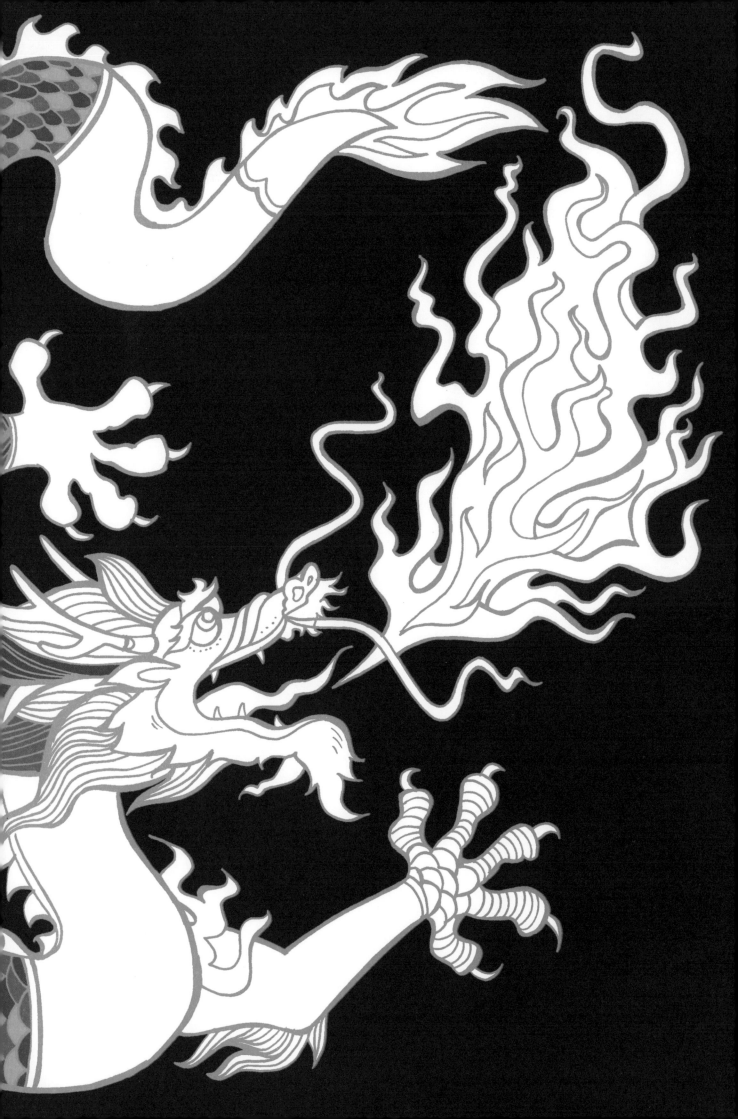

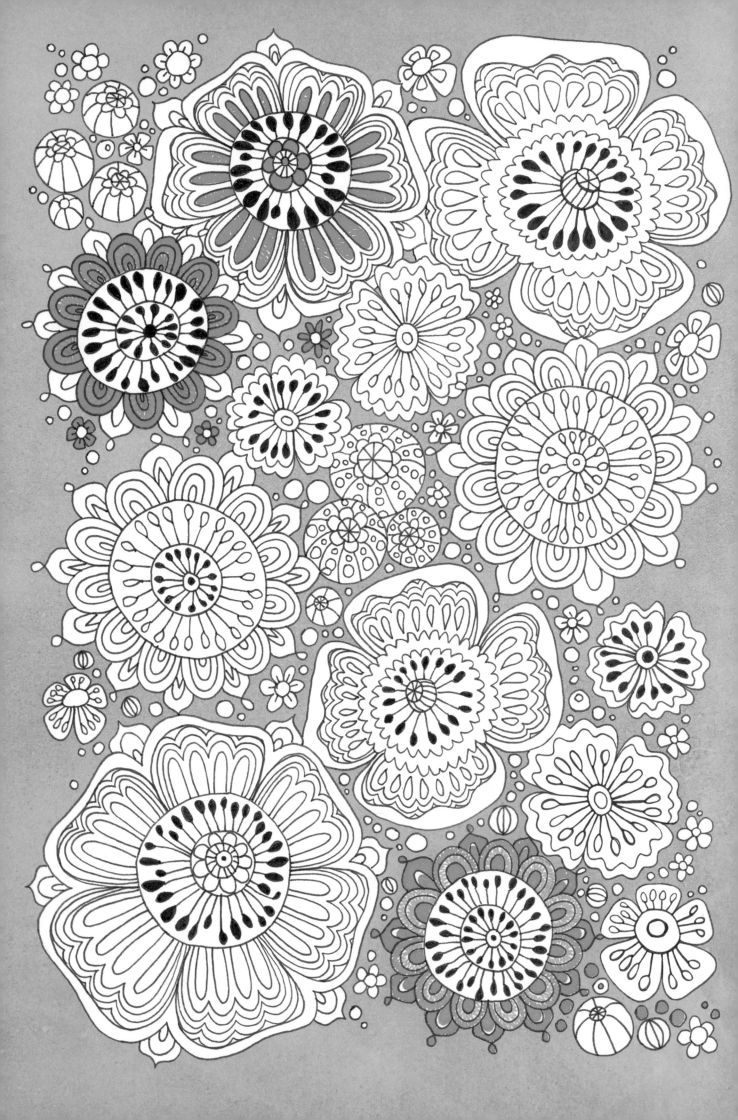

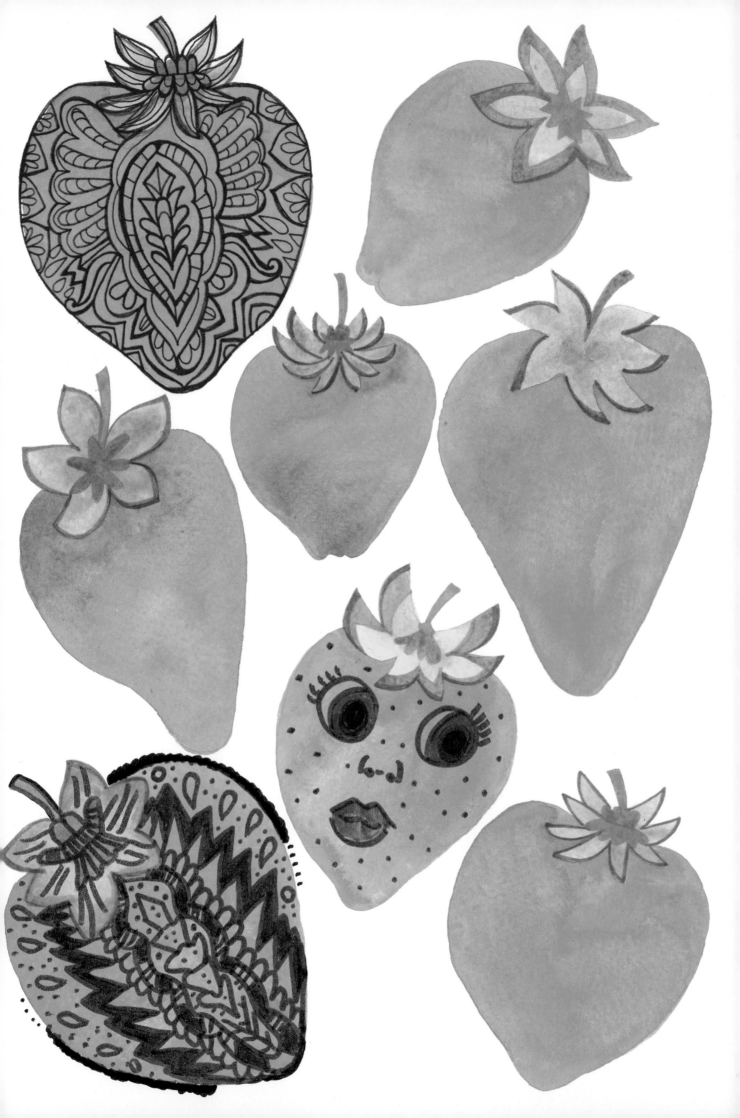

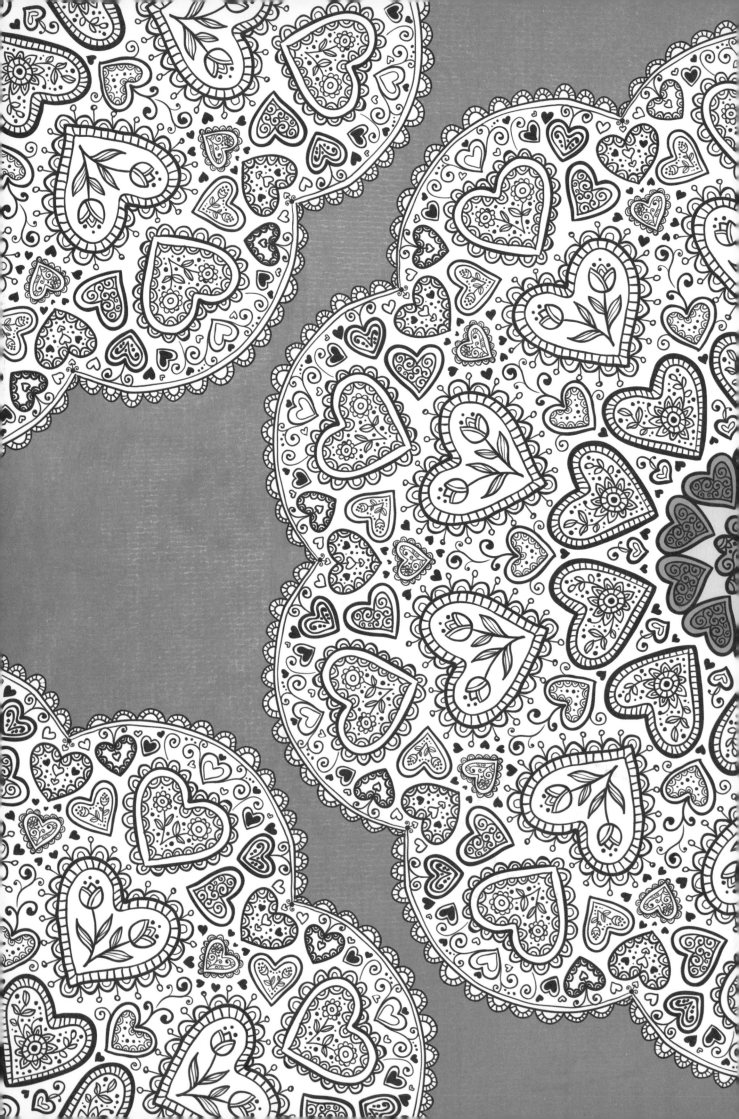

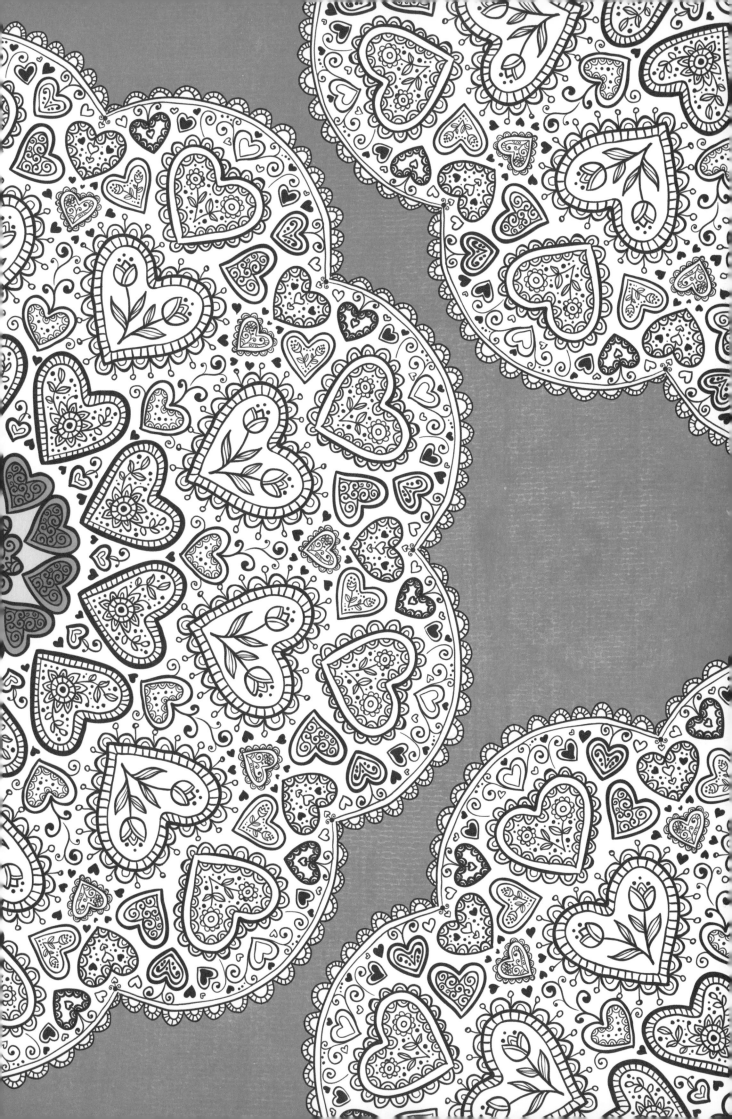

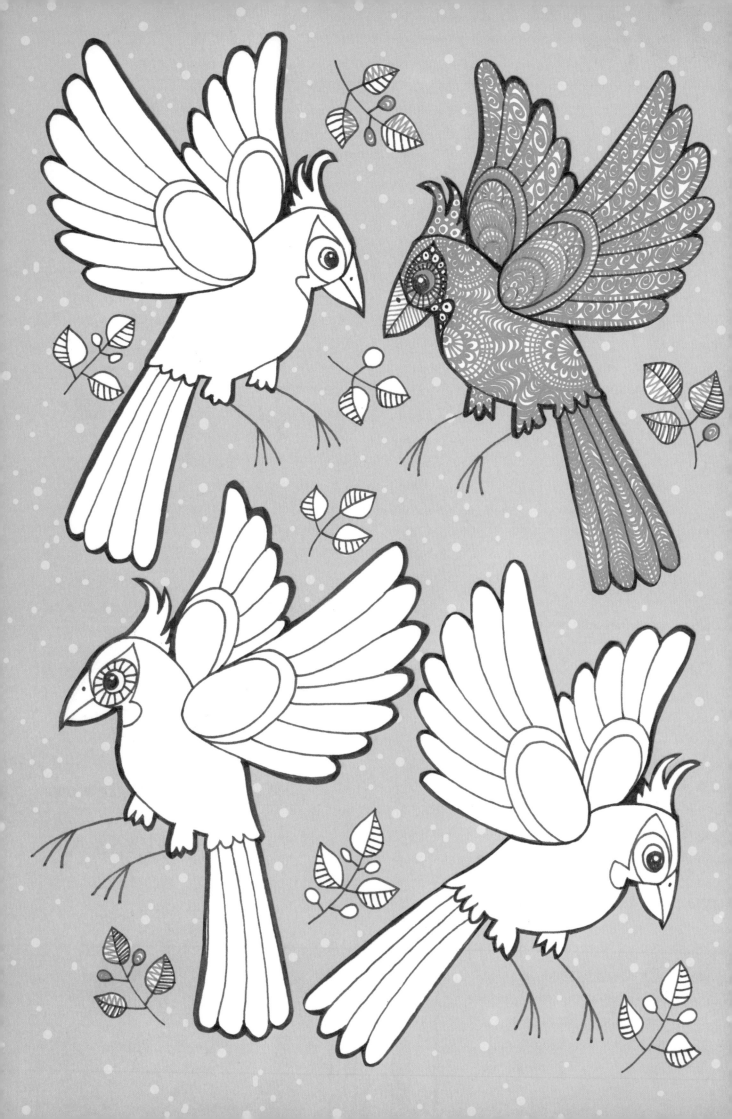

ORANGE

Orange glows ... from the burnt, rusty hues of autumn to a sultry, summer sunset. It can be a warm, calming colour but it's also zesty and determined.

COMPLEMENTARY COLOUR:
BLUE

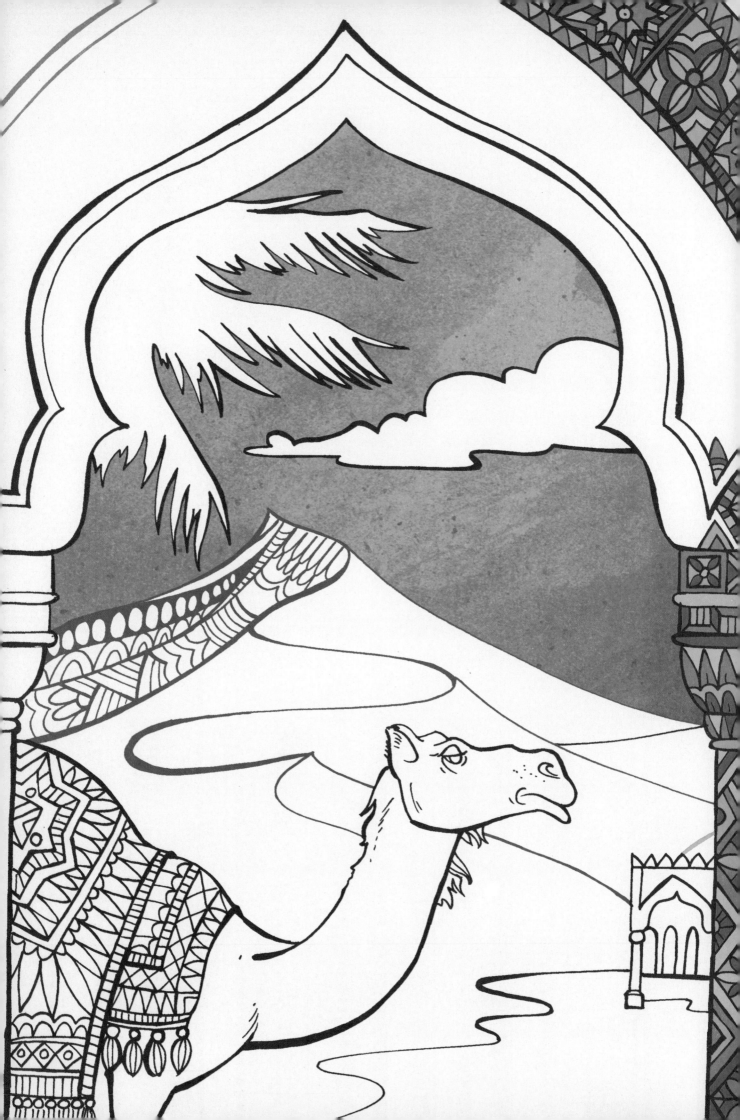

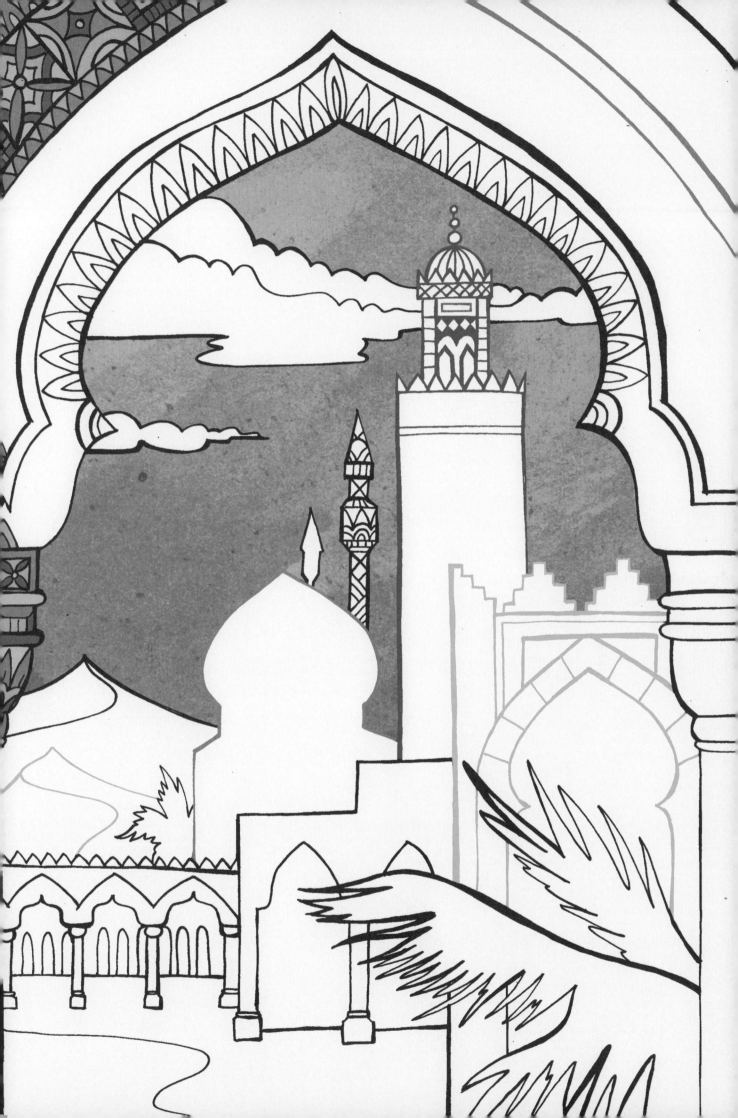

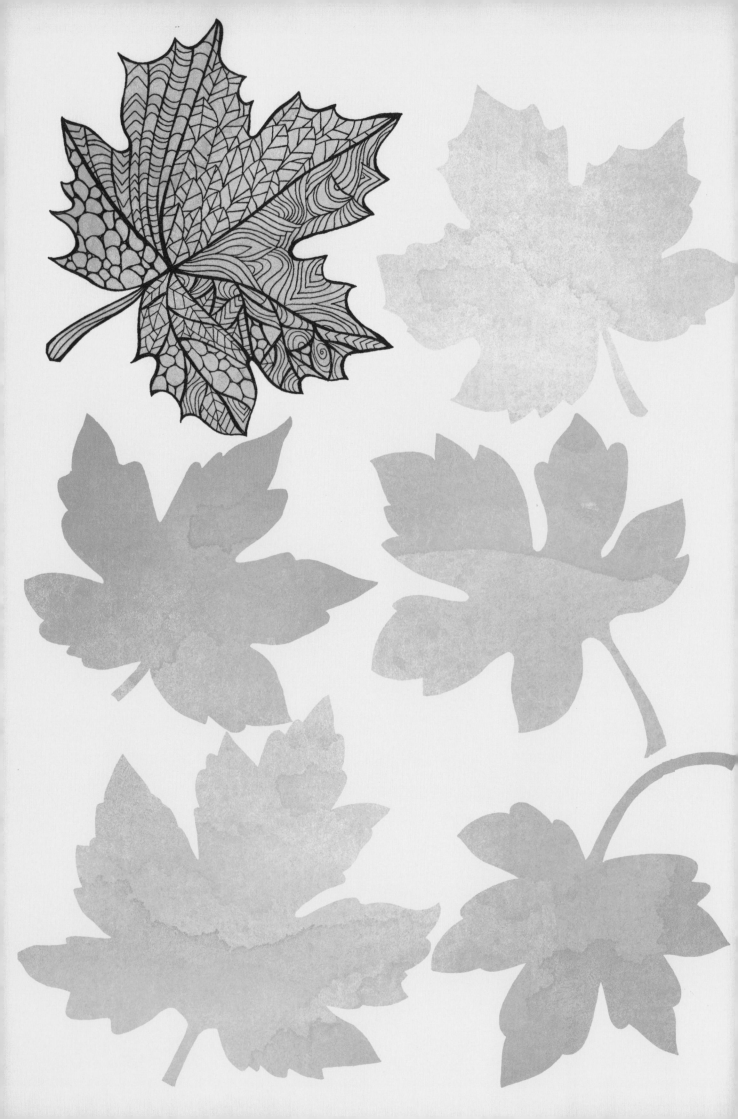

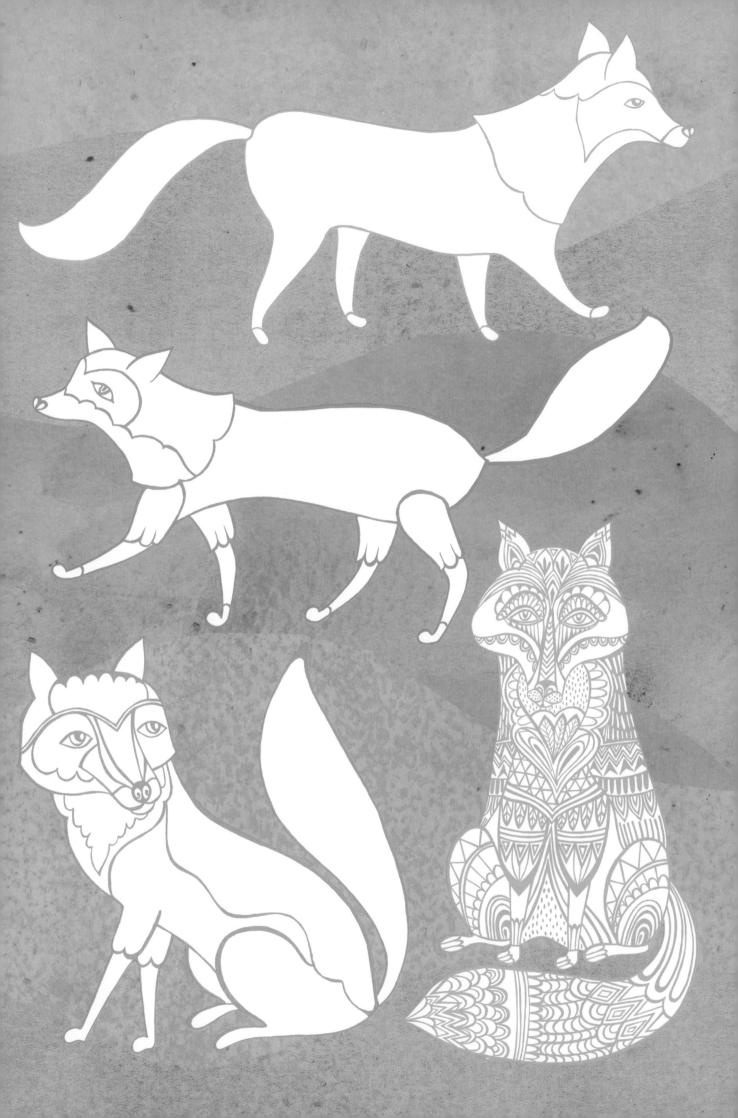

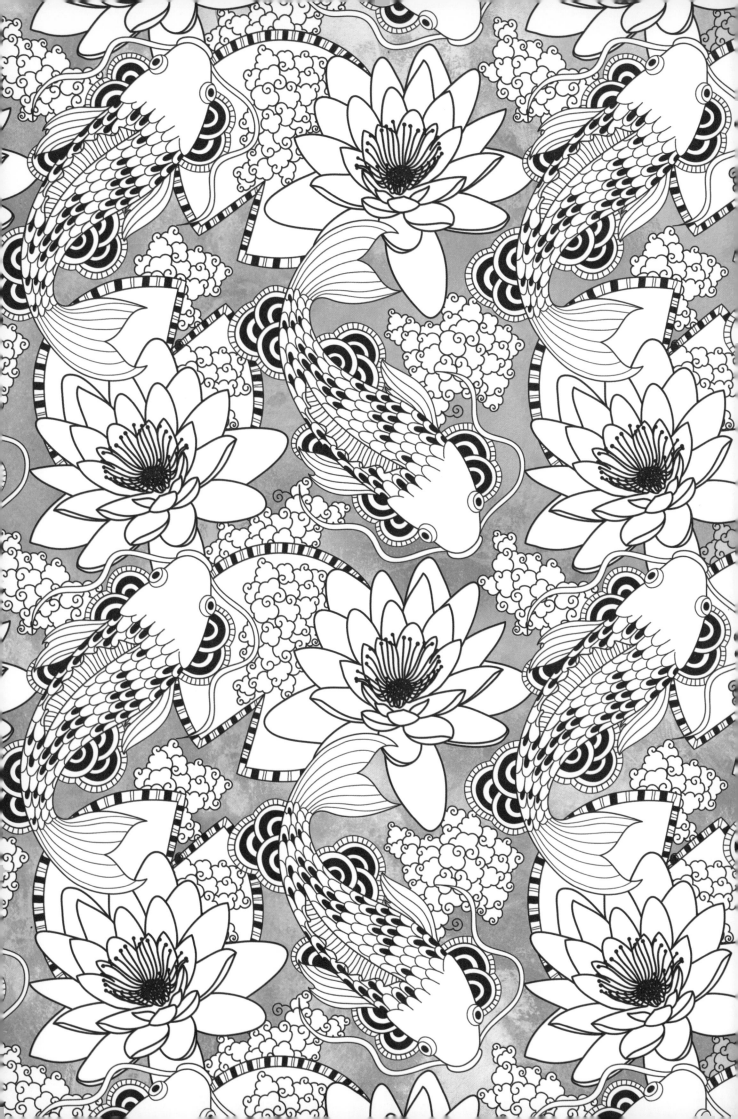

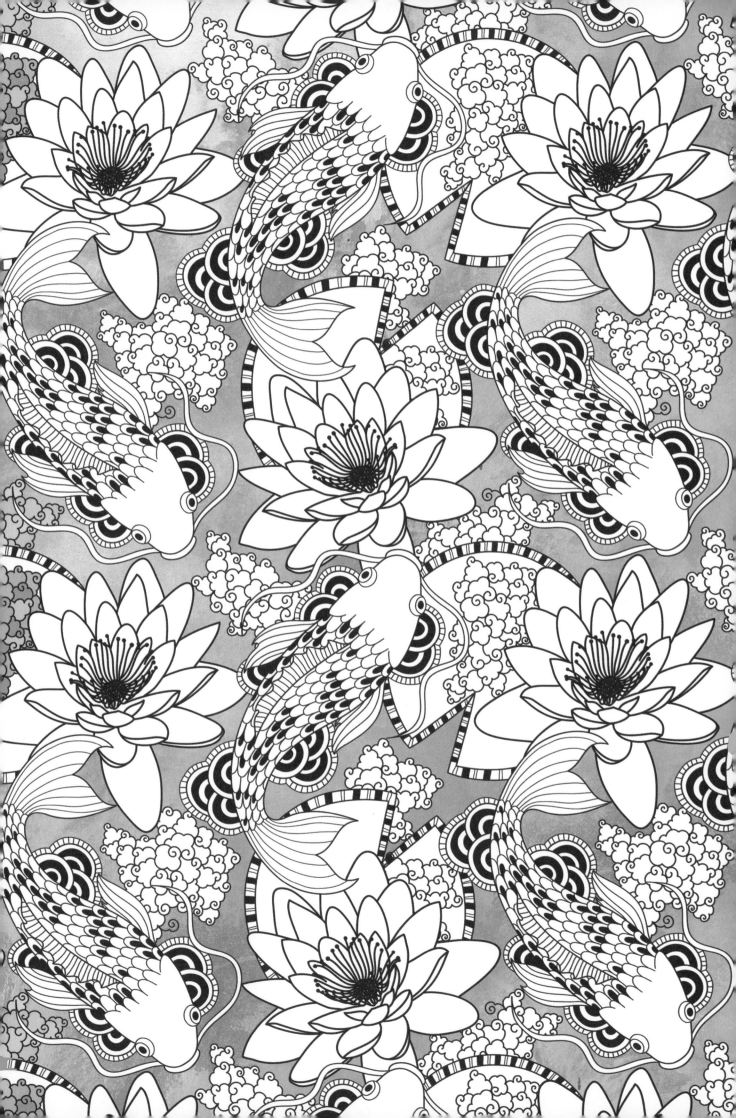

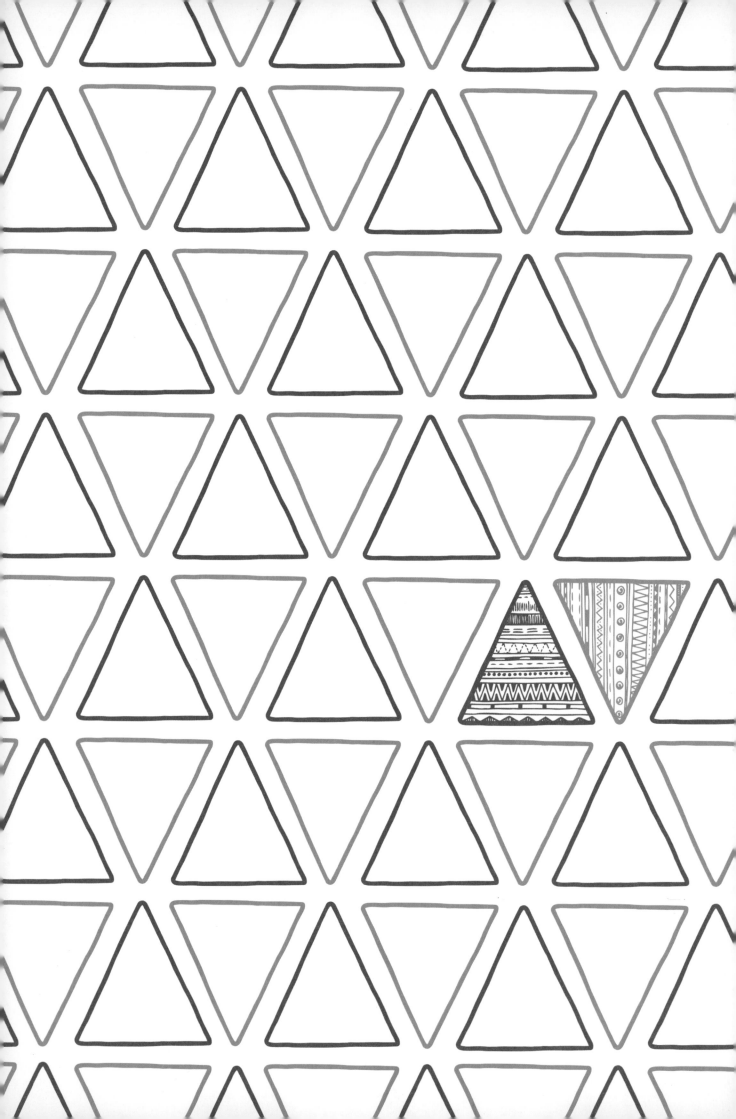

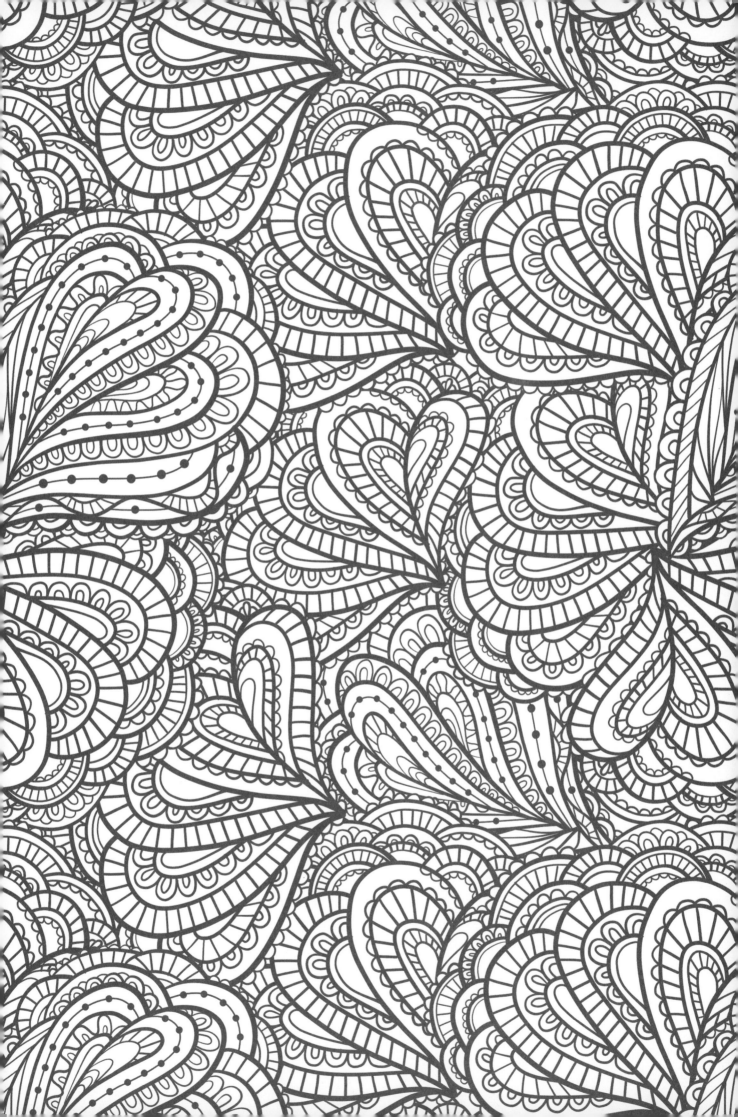

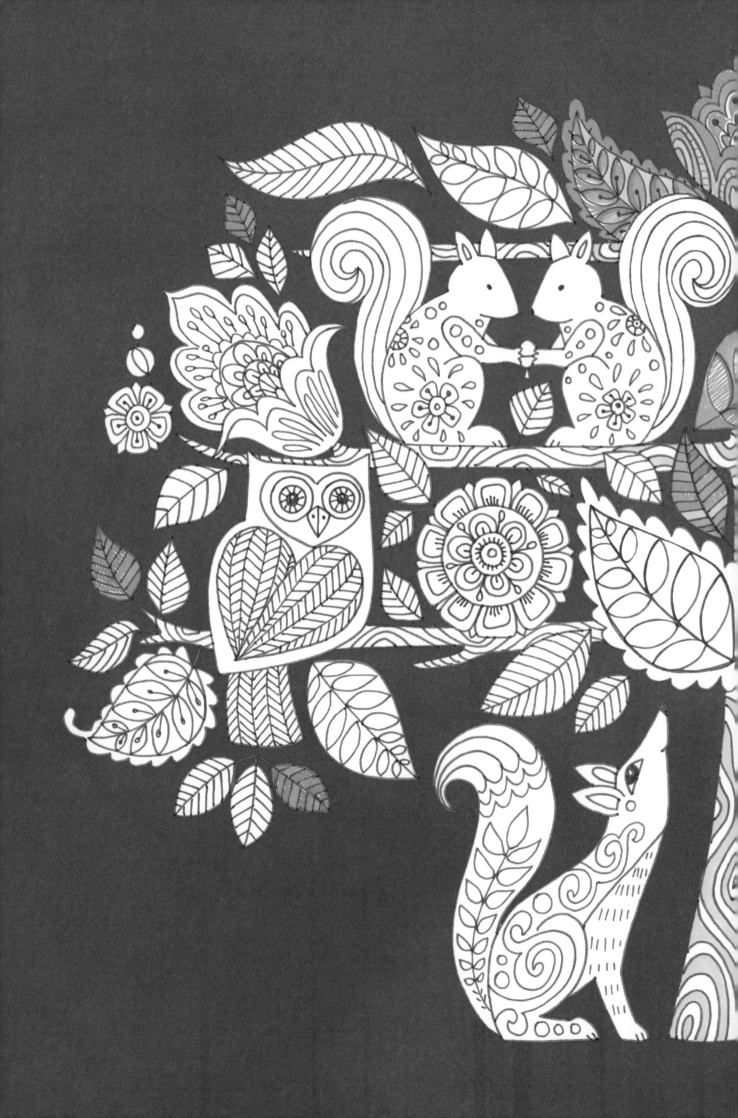

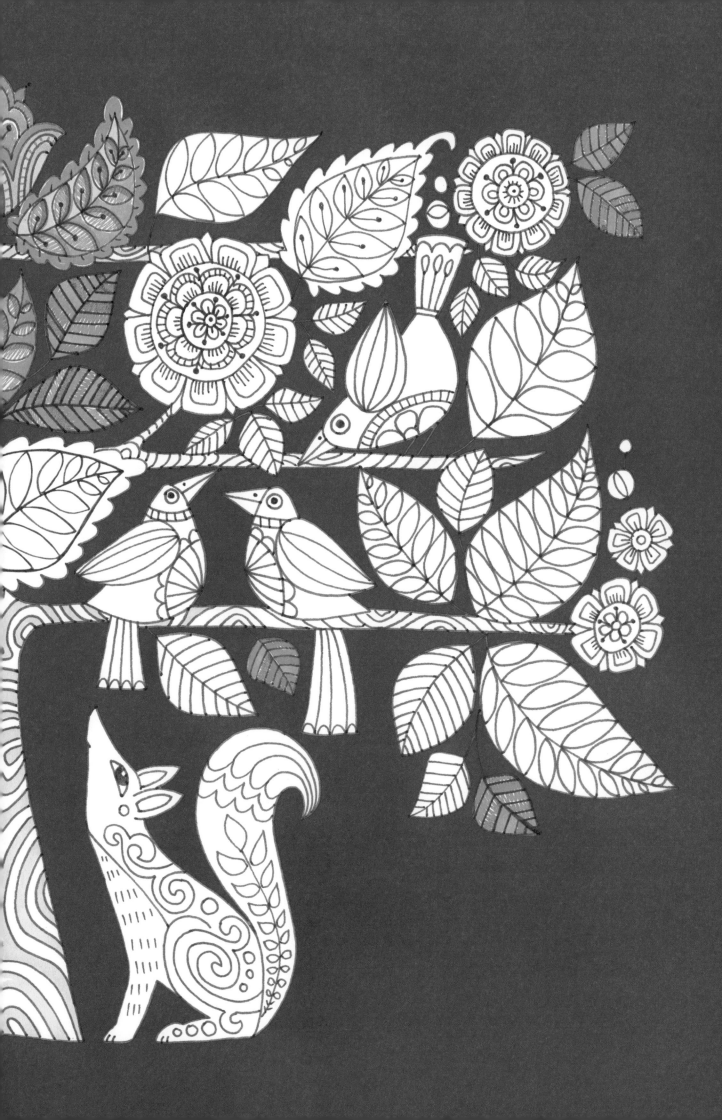

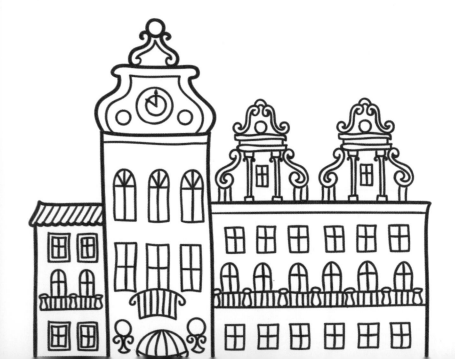

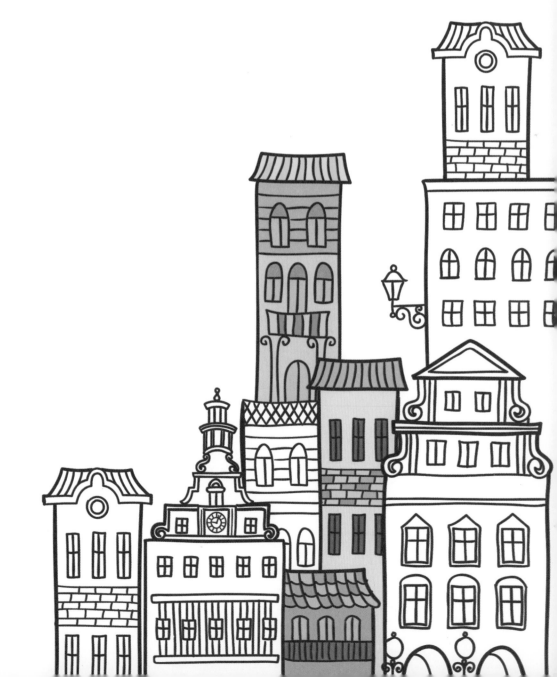

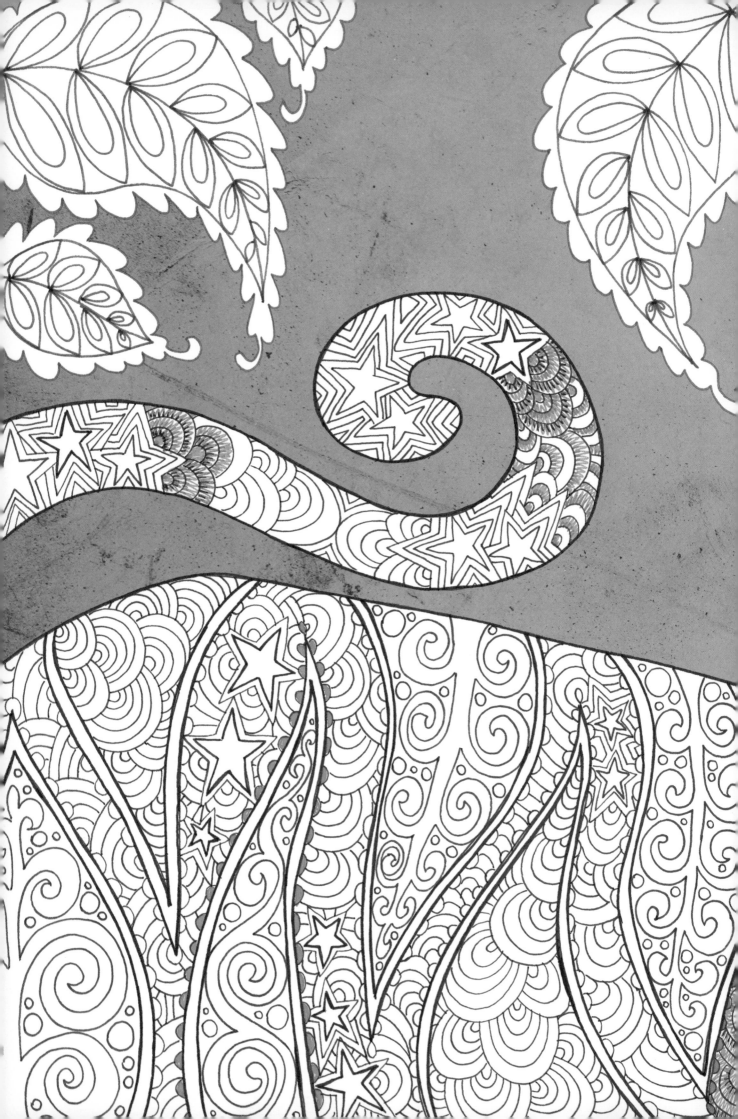

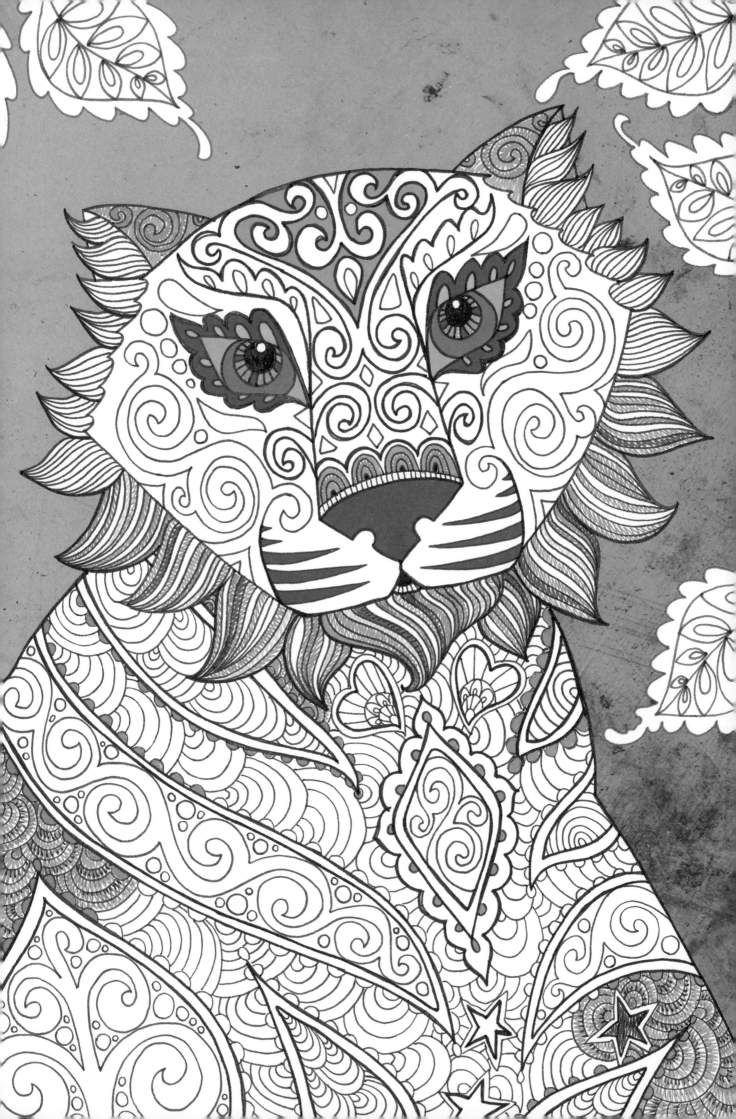

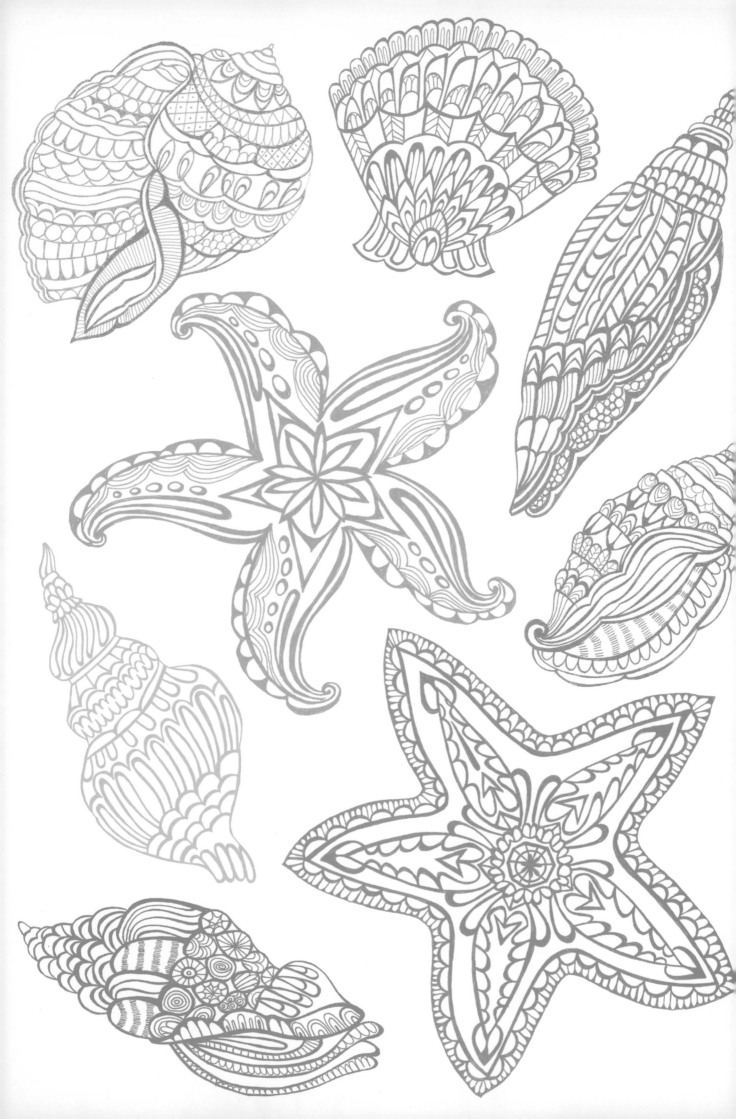

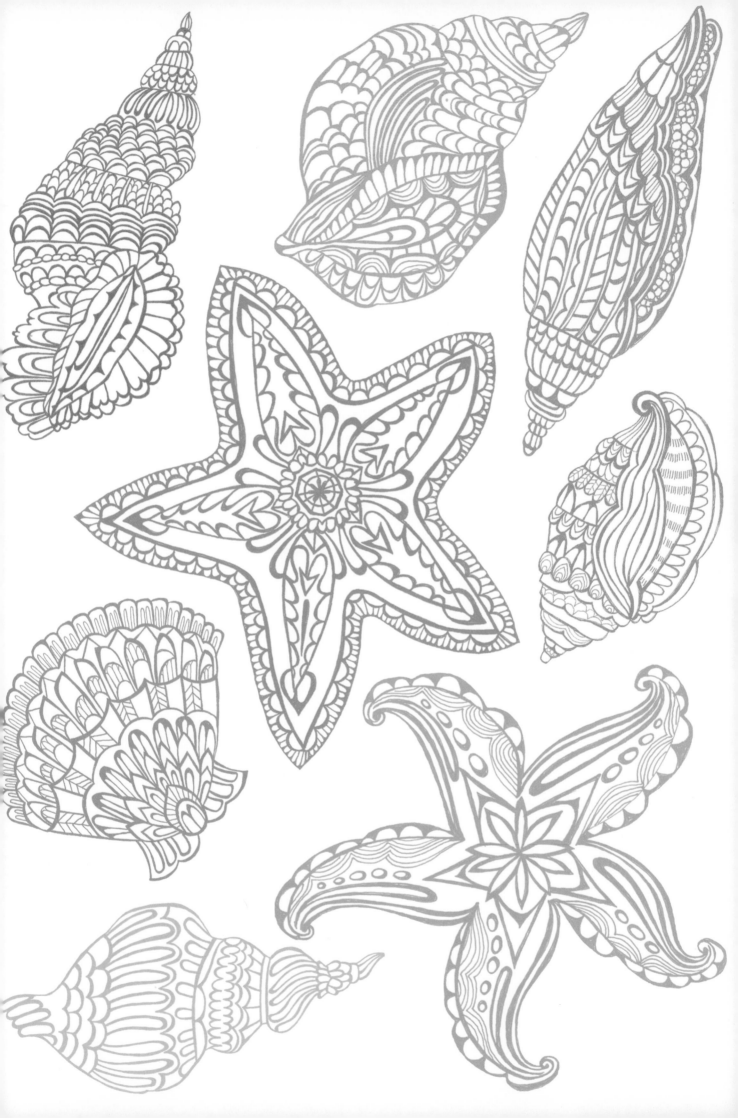

YELLOW

Yellow is a burst of happiness. From glorious sunshine and golden sands to fields of sunflowers or the flash of a butterfly's wing, it's a colour that never fails to catch our attention.

COMPLEMENTARY COLOUR:

PURPLE

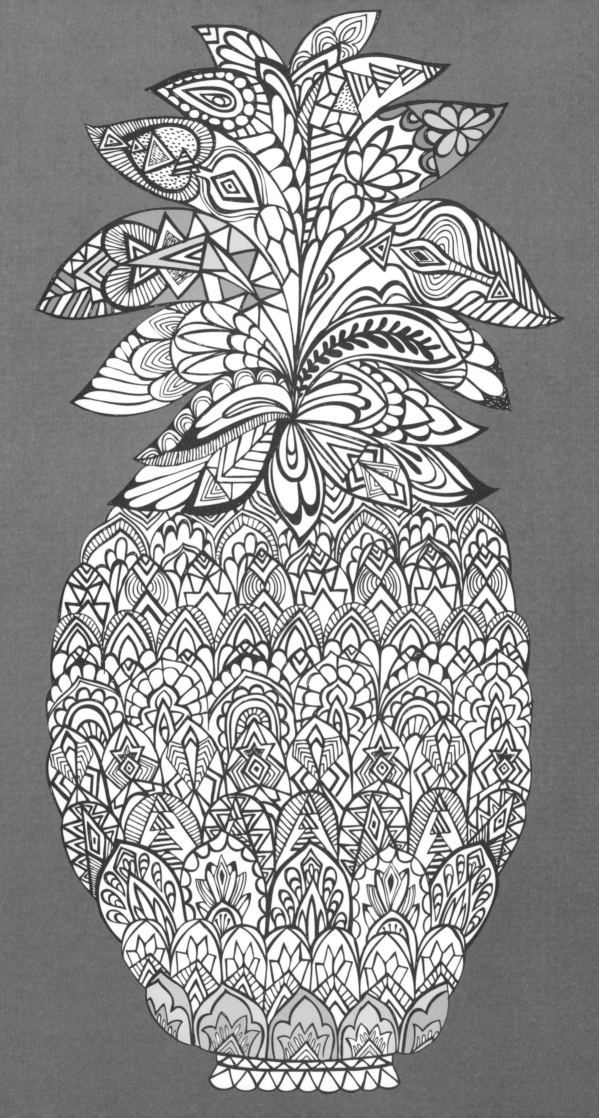

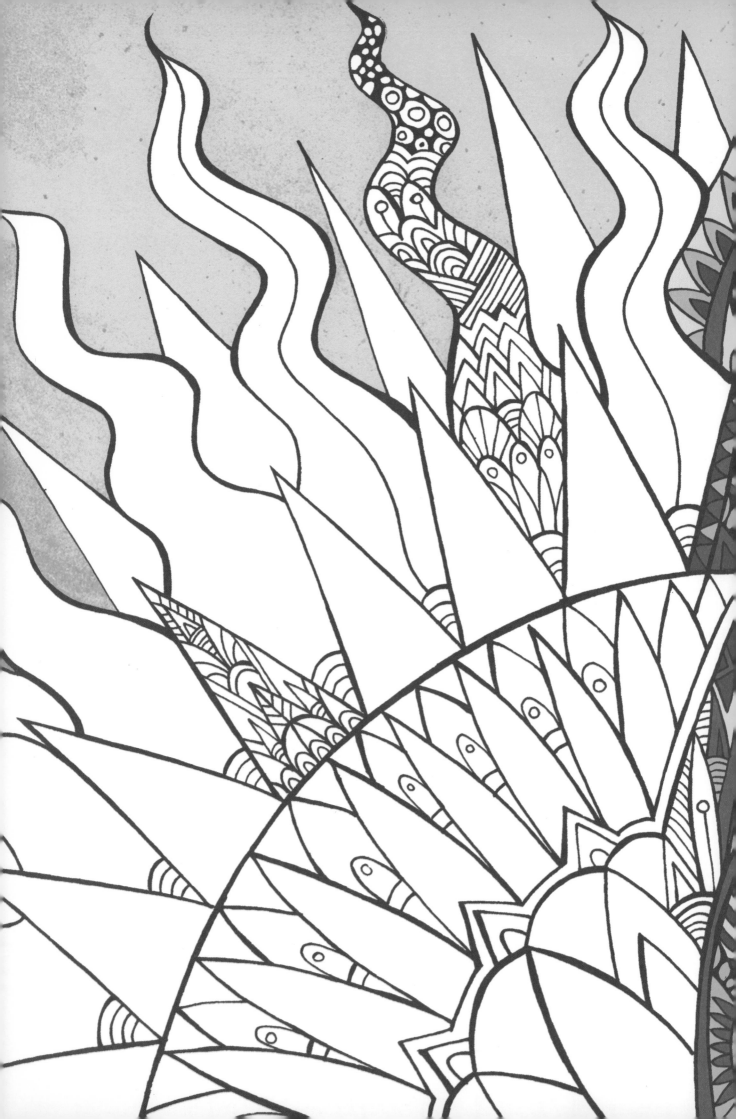

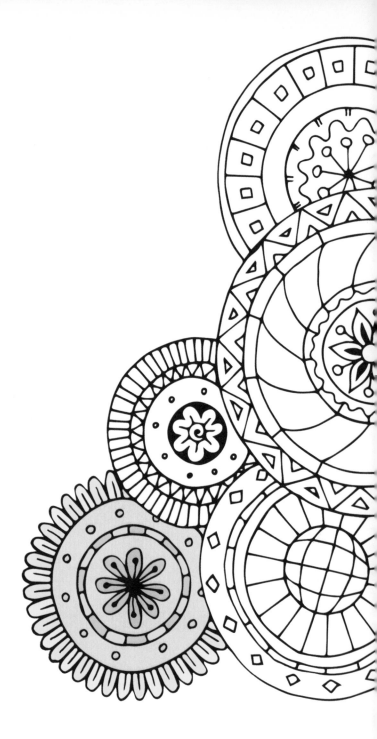

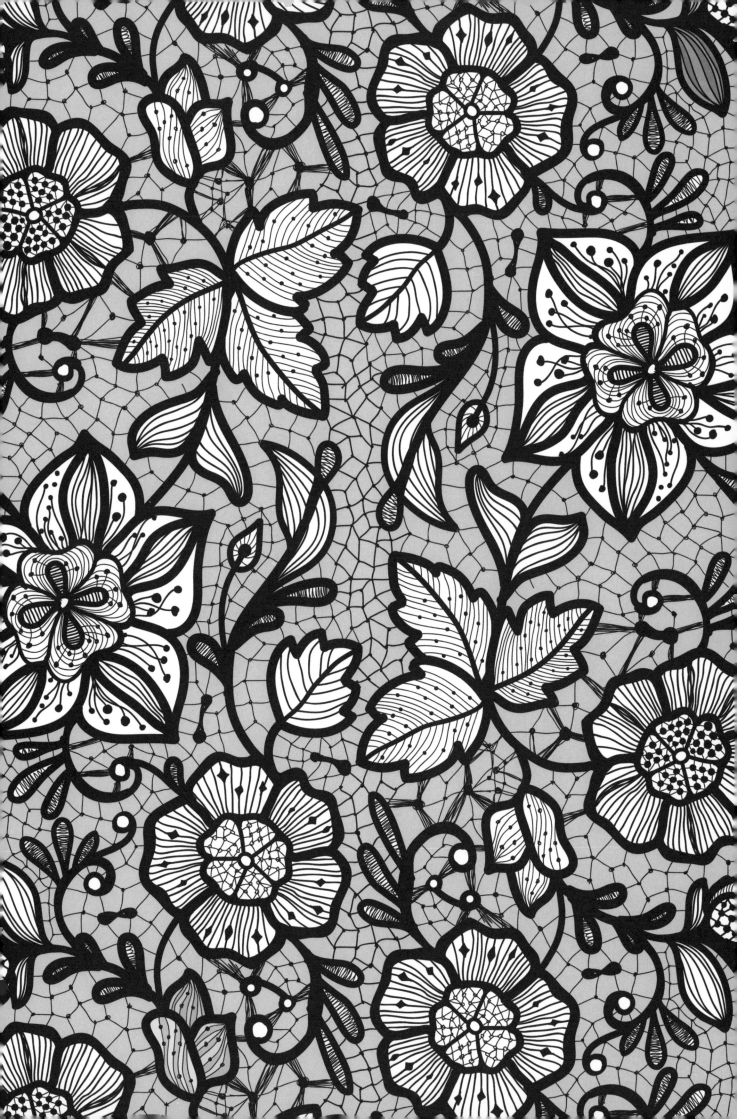

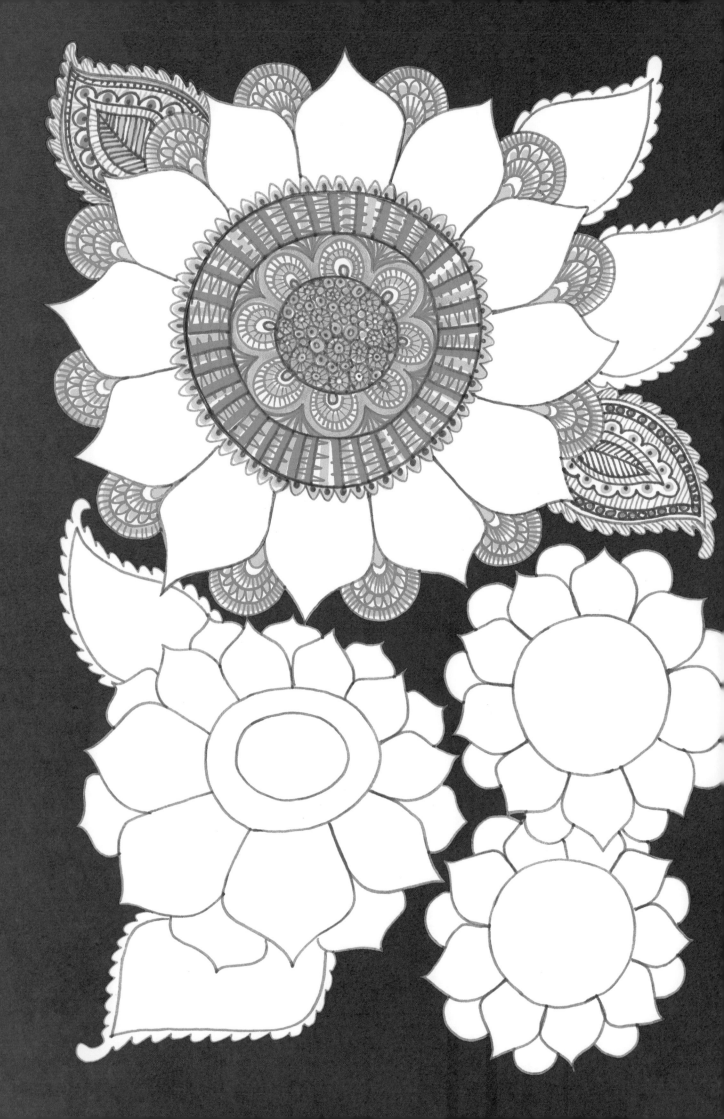

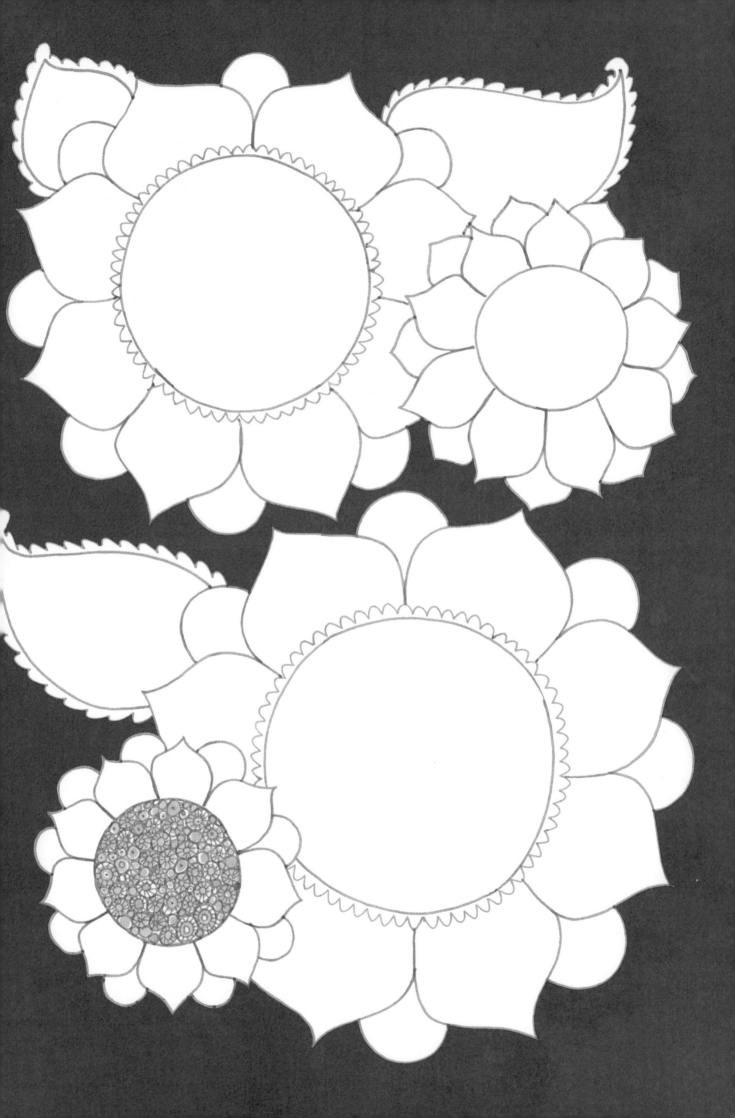

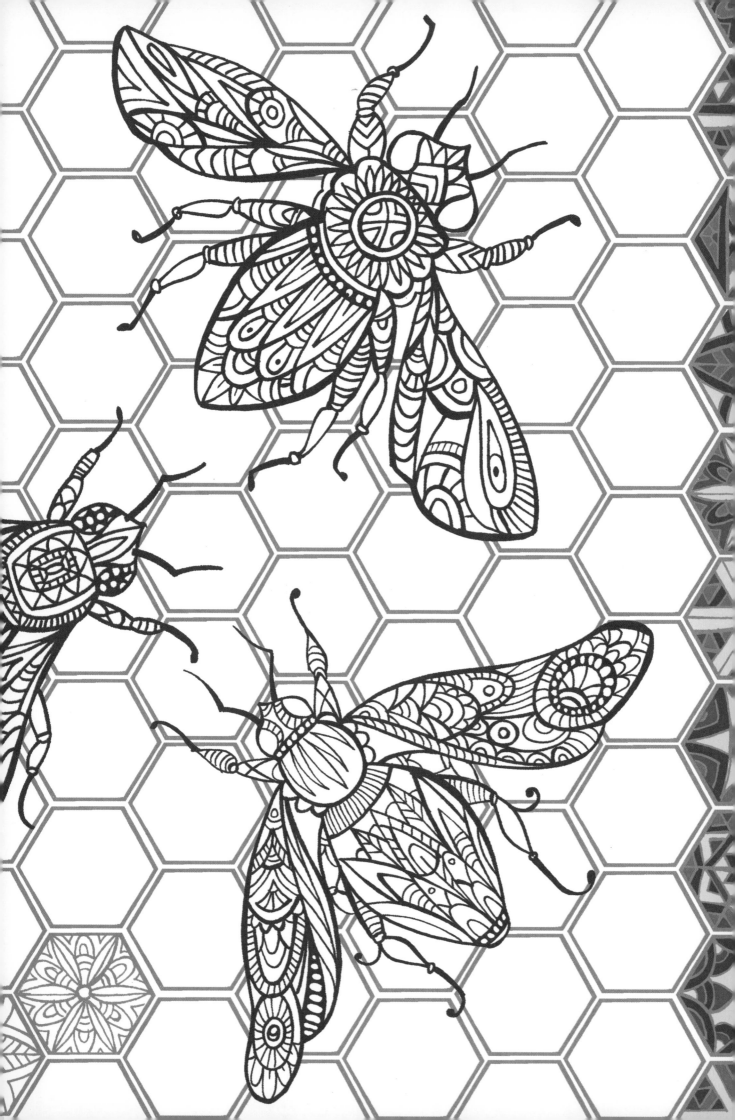

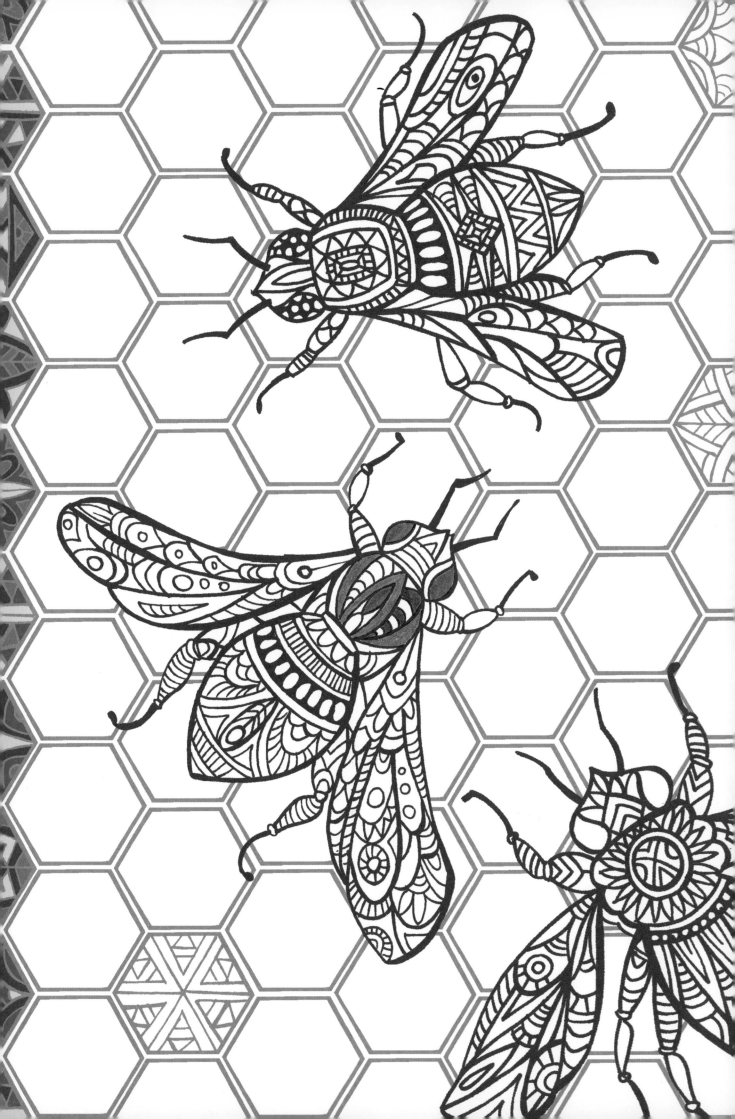

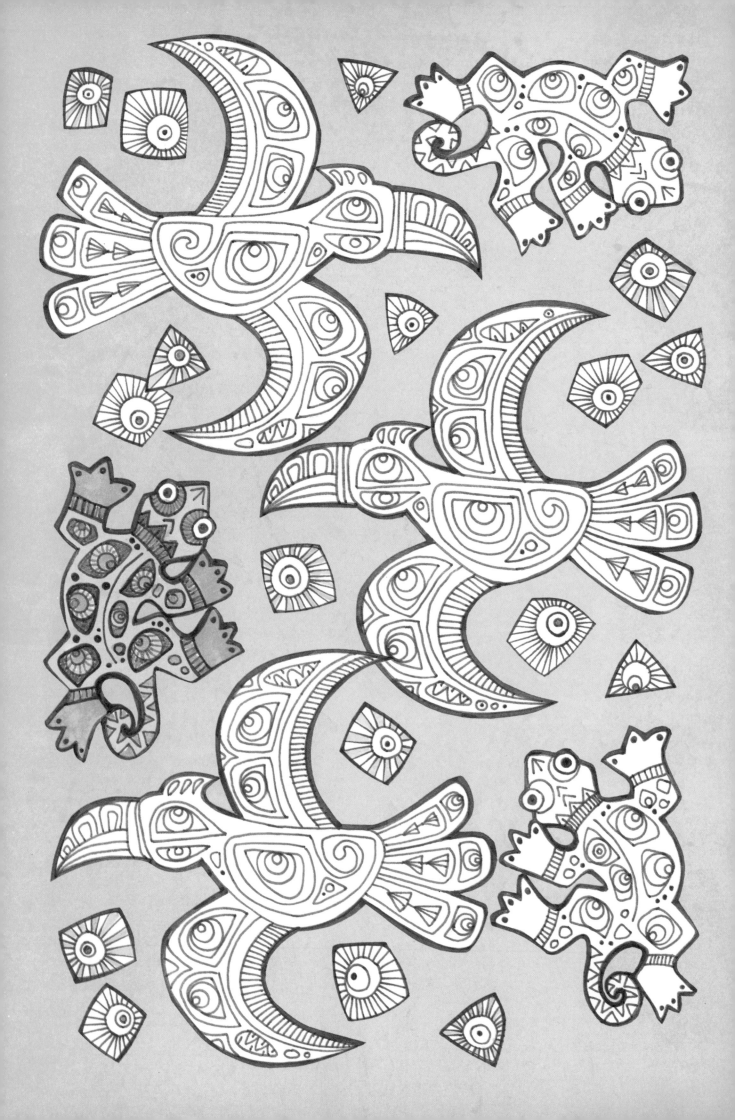

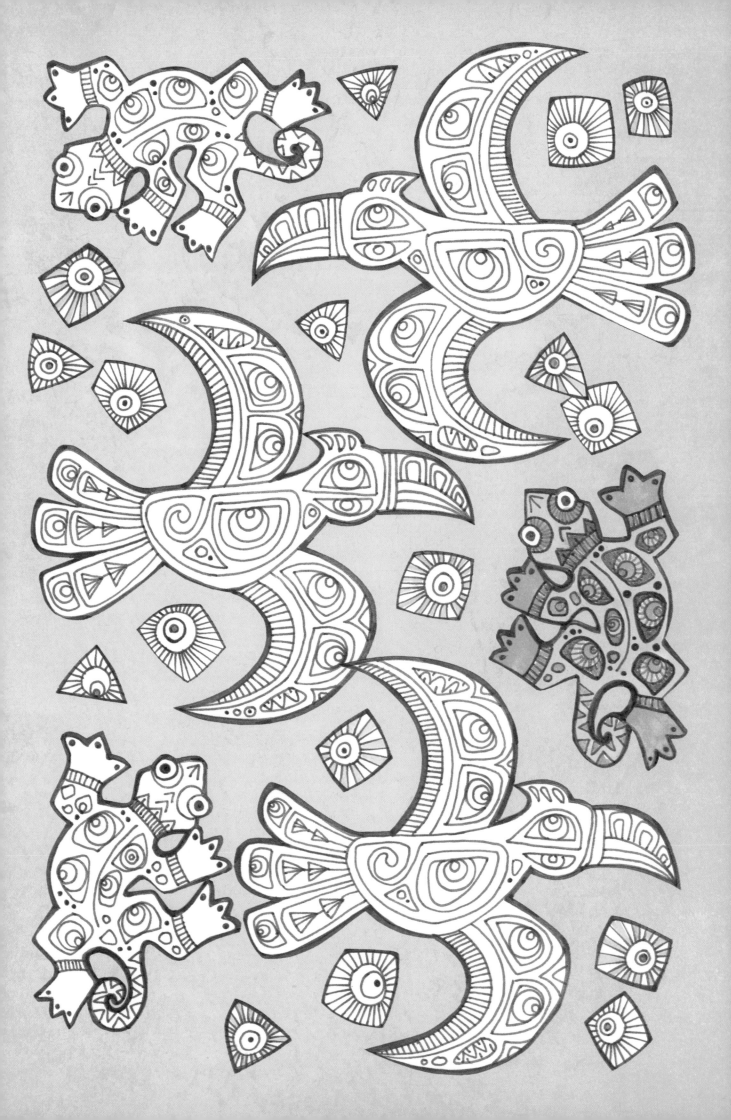

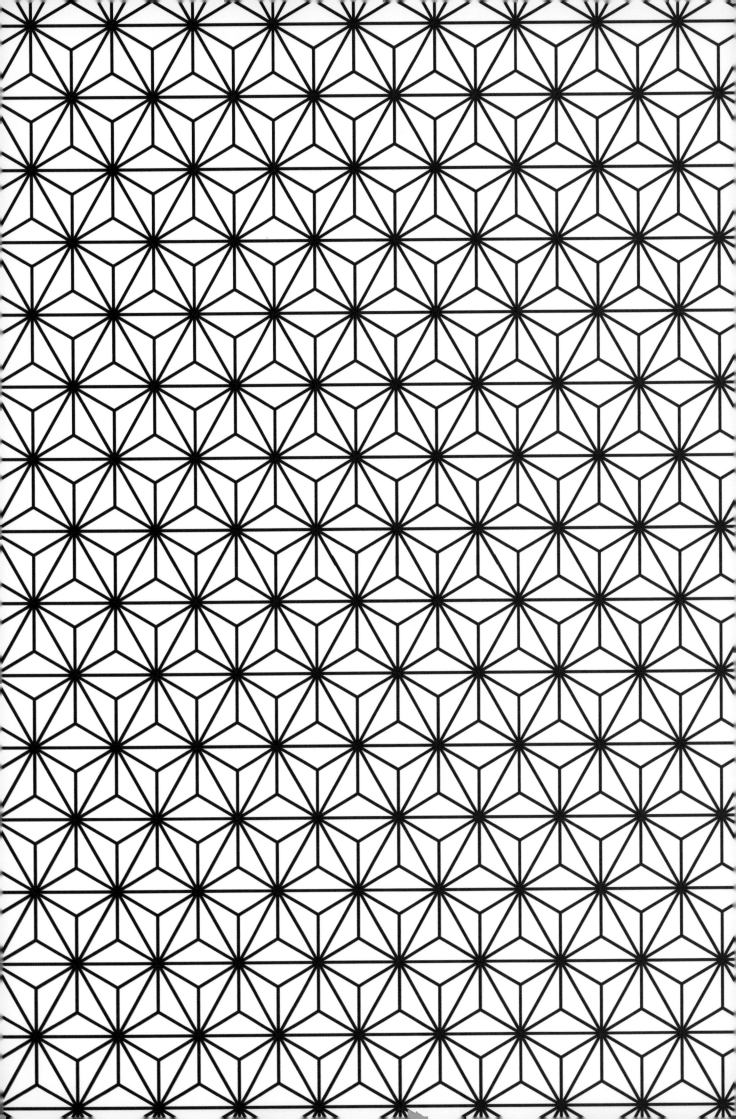

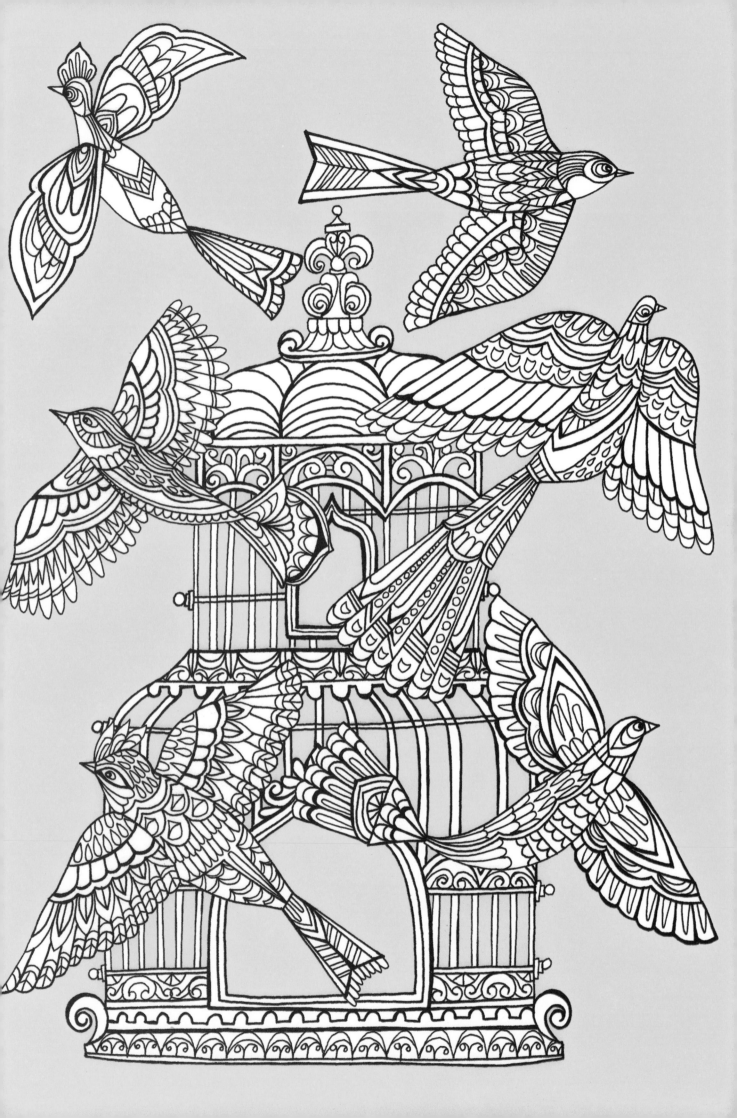

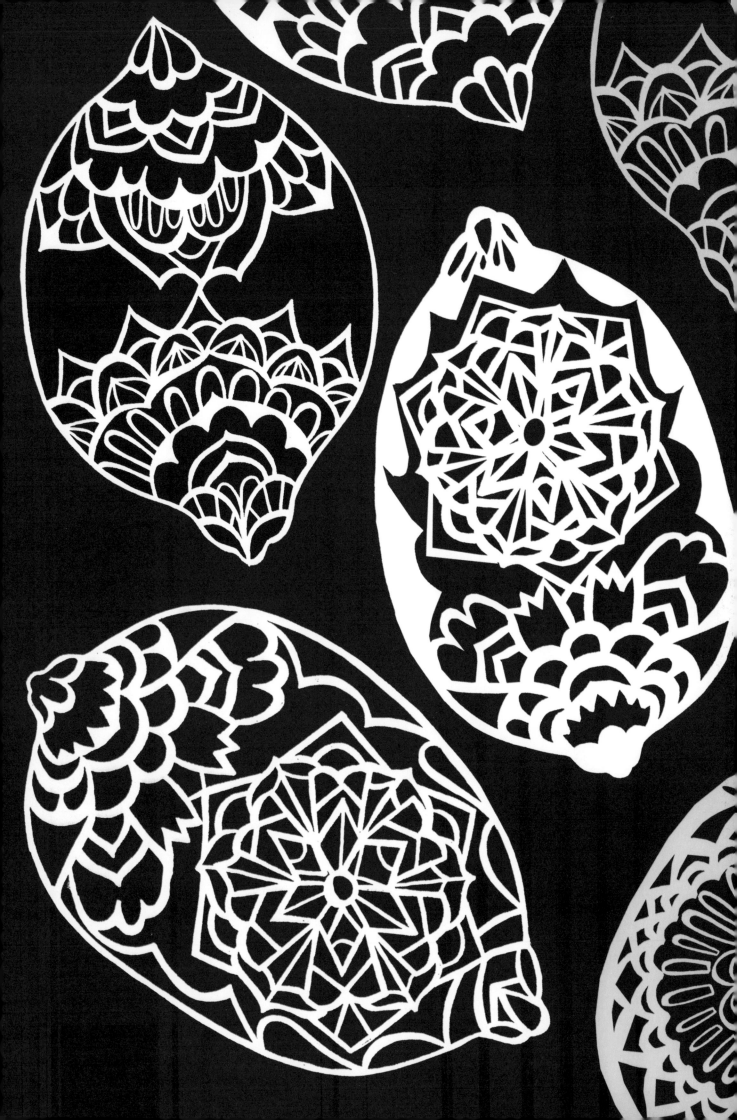

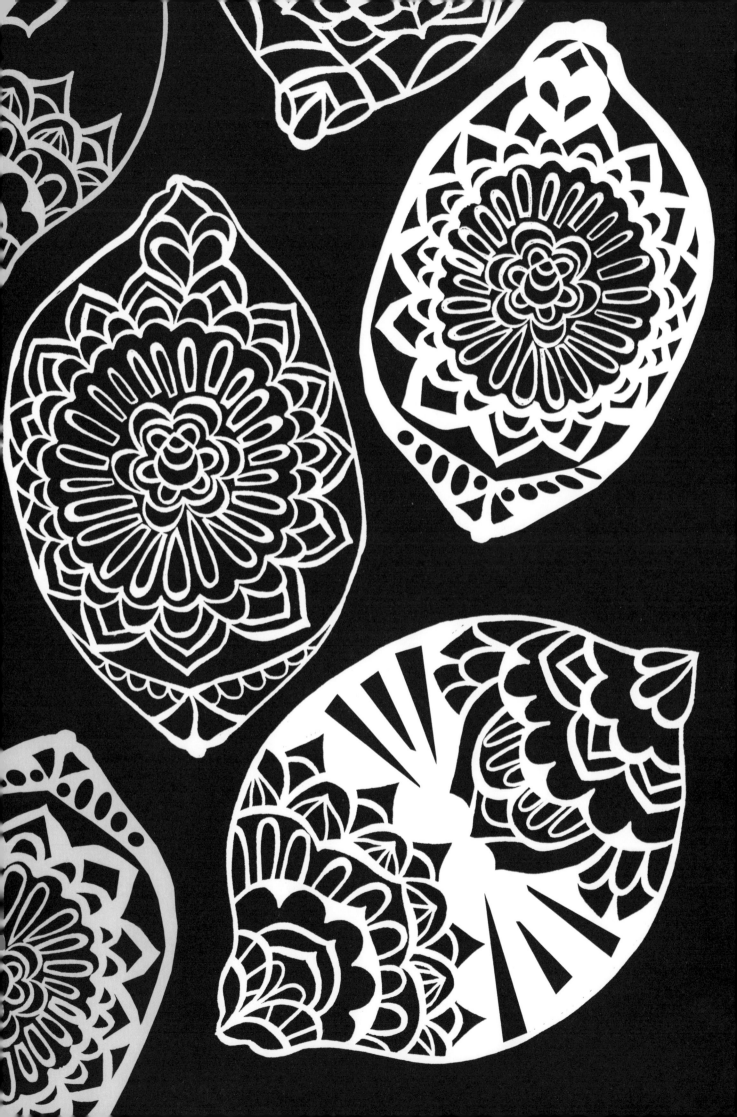

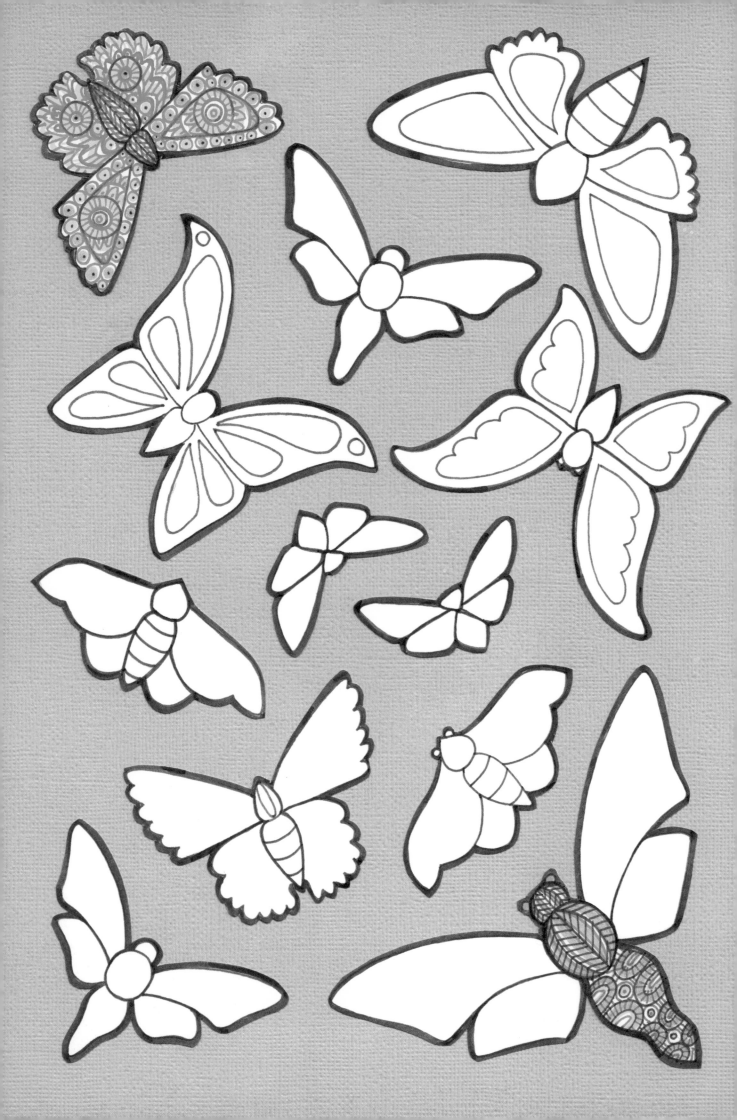

GREEN

From deep, majestic forests and verdant
valleys to zesty limes and crisp apples,
green is the colour of the natural world.
It's harmonizing, peaceful and refreshing.

COMPLEMENTARY COLOUR:
RED

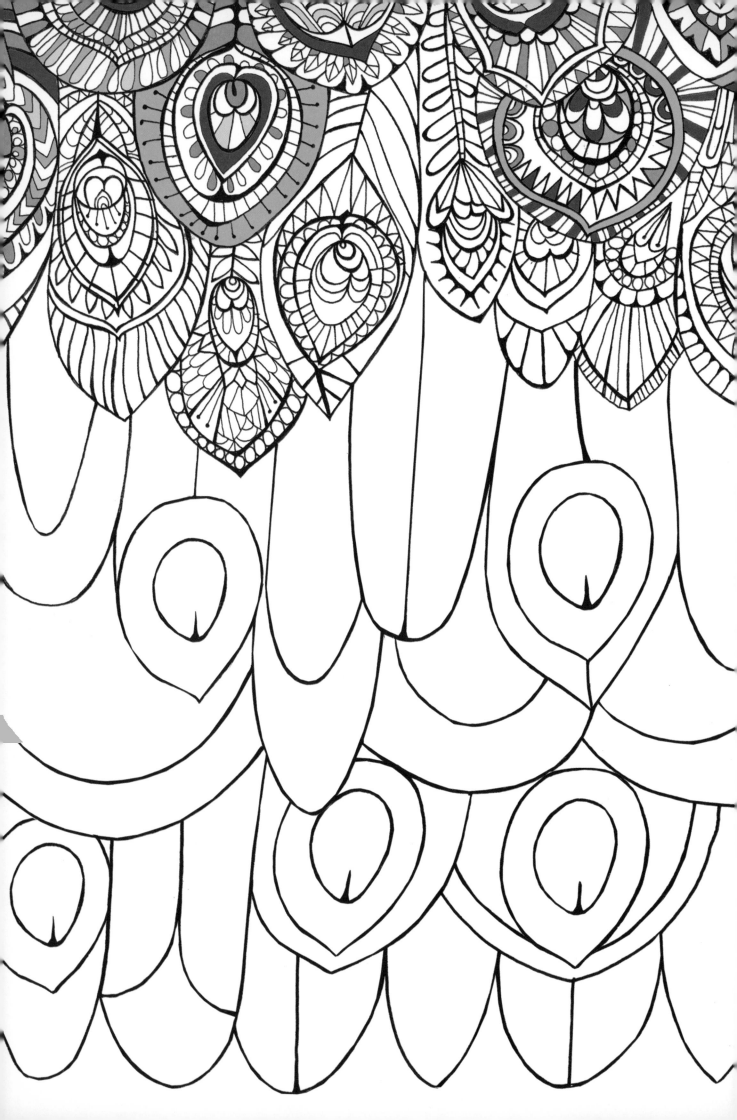

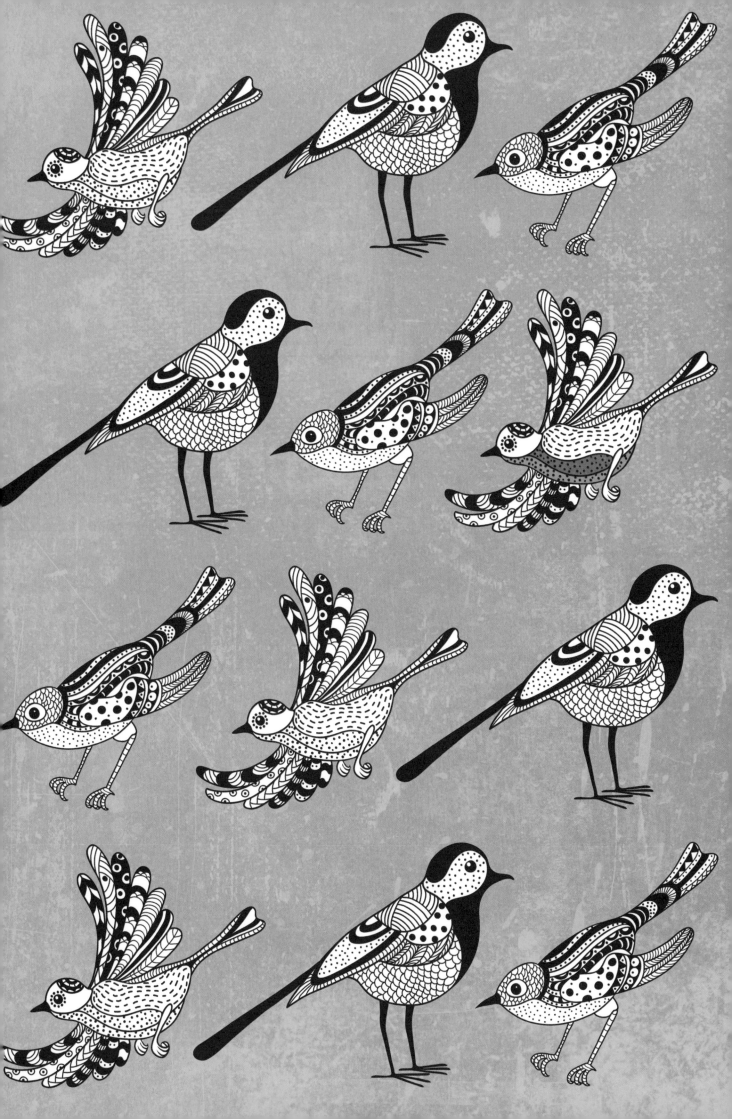

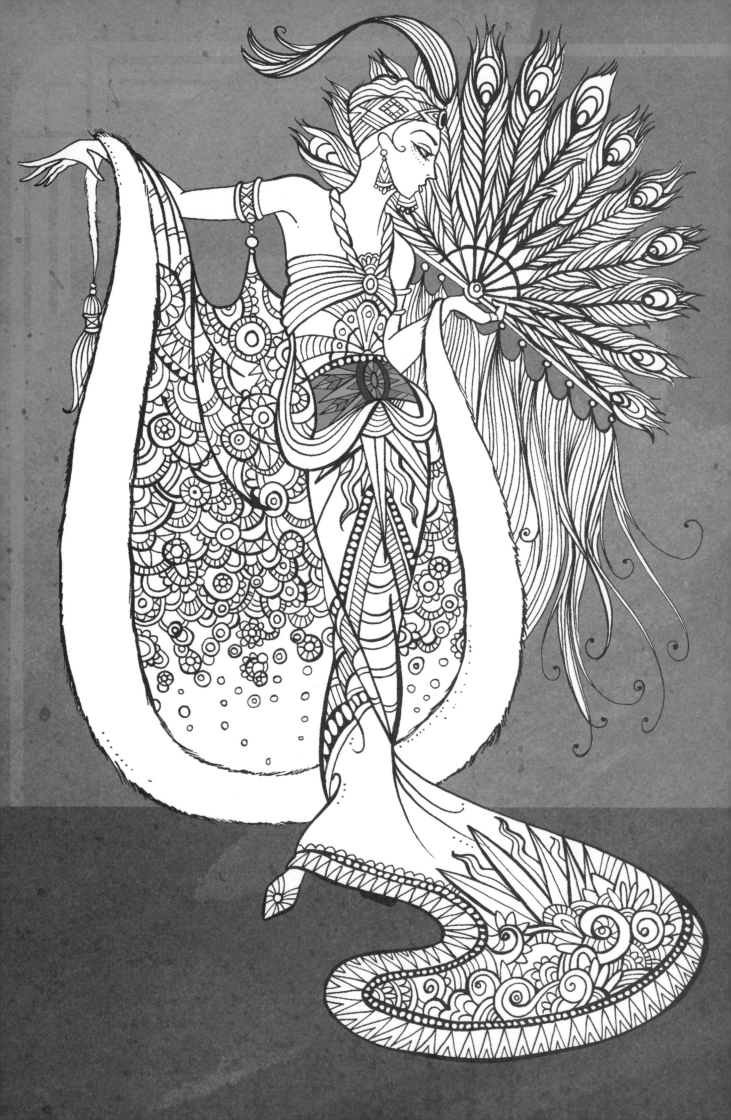

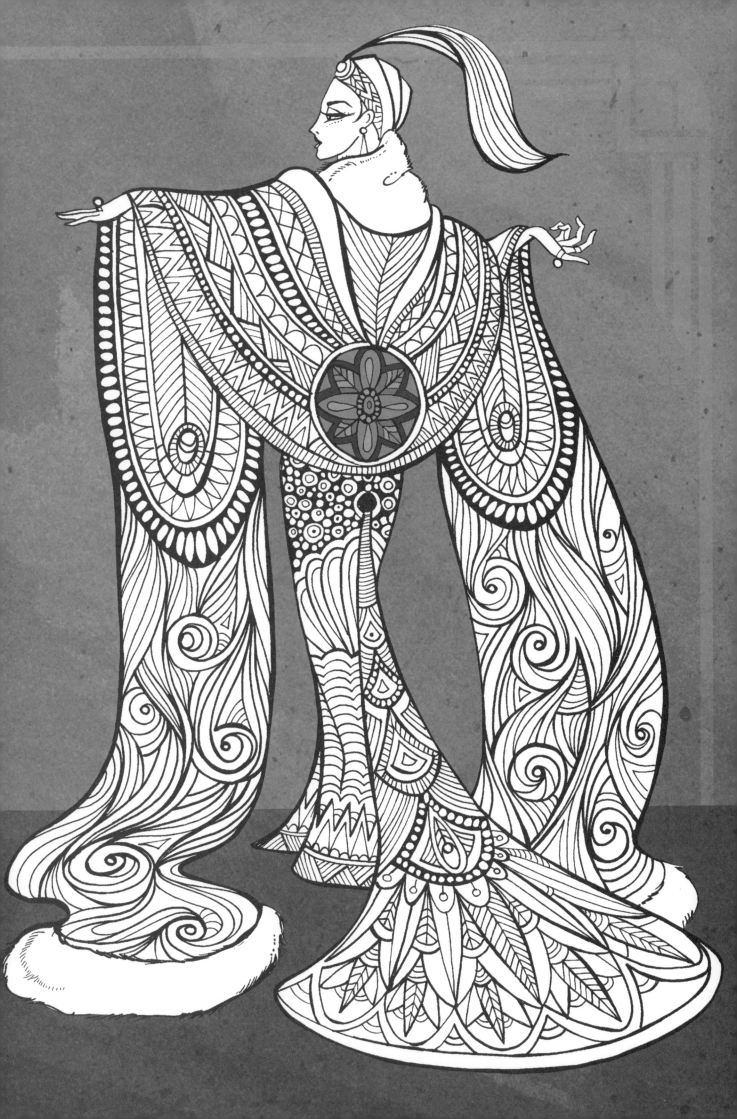

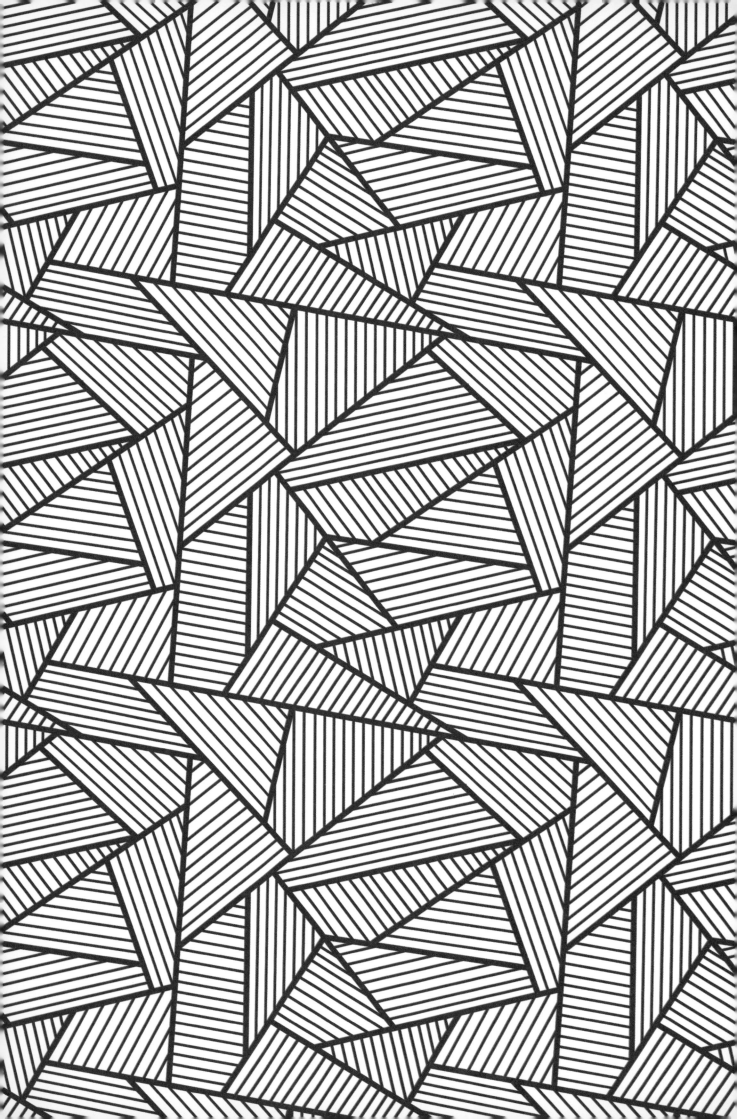

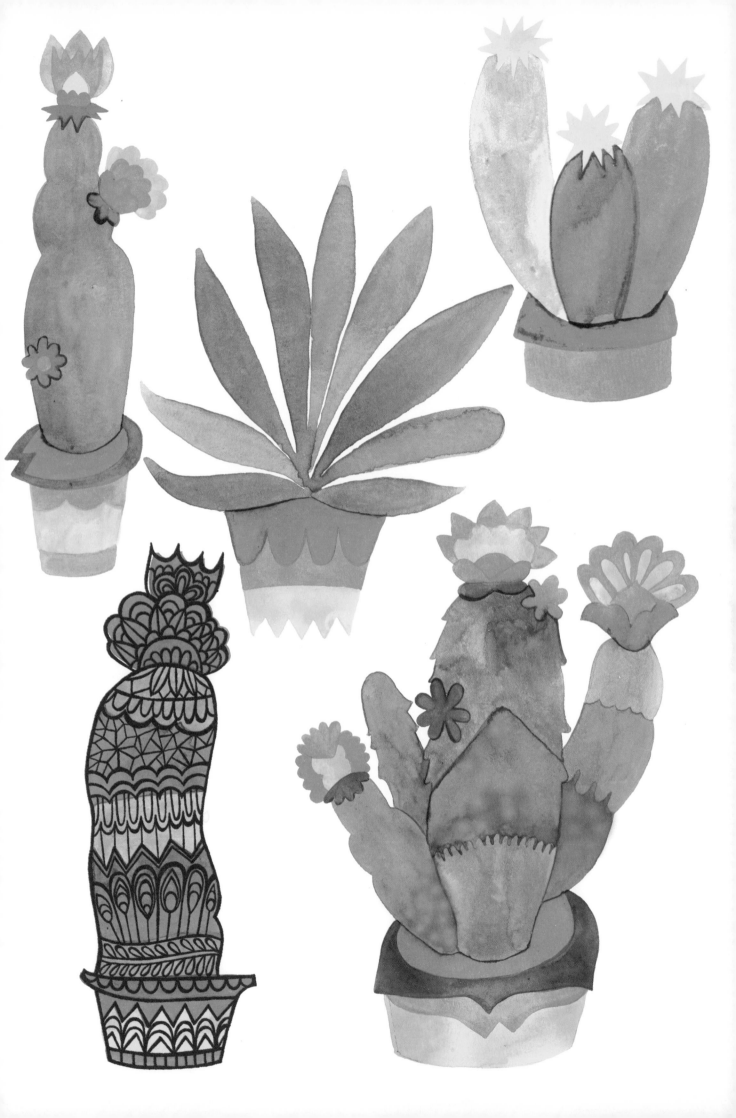

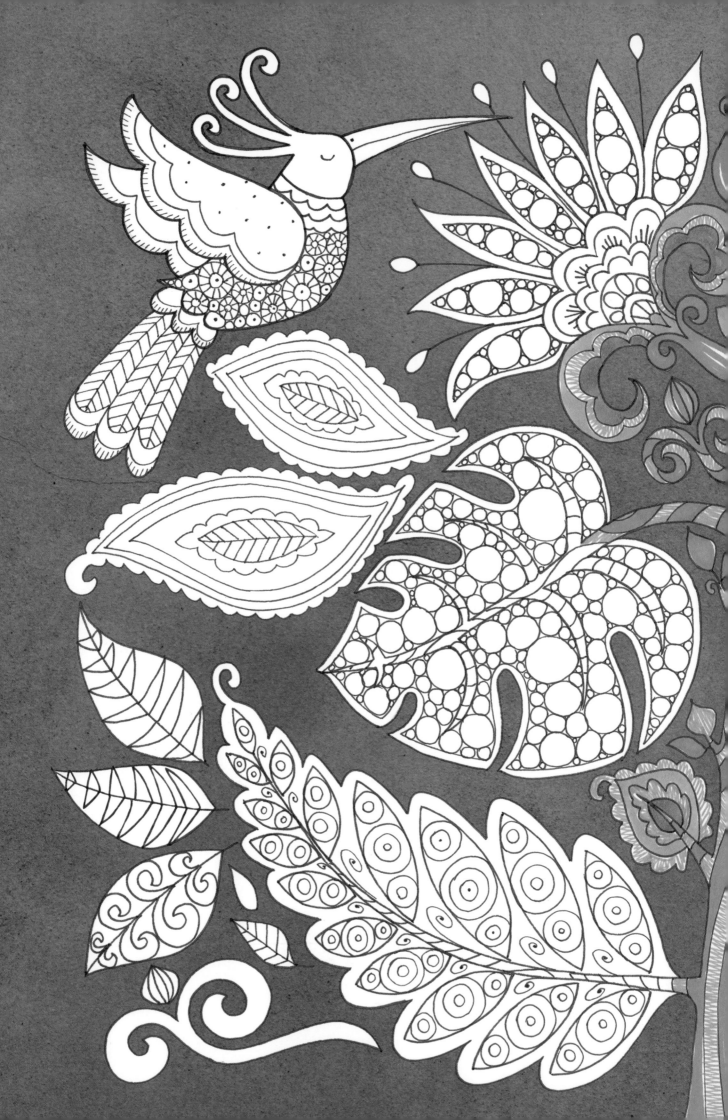

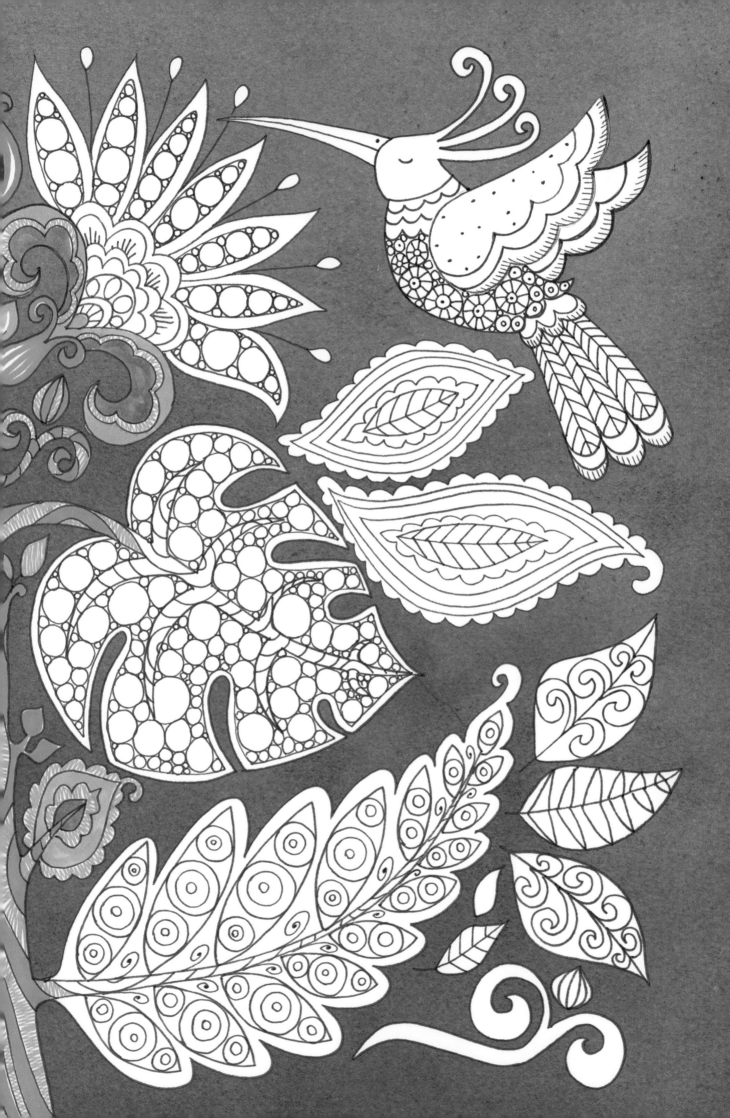

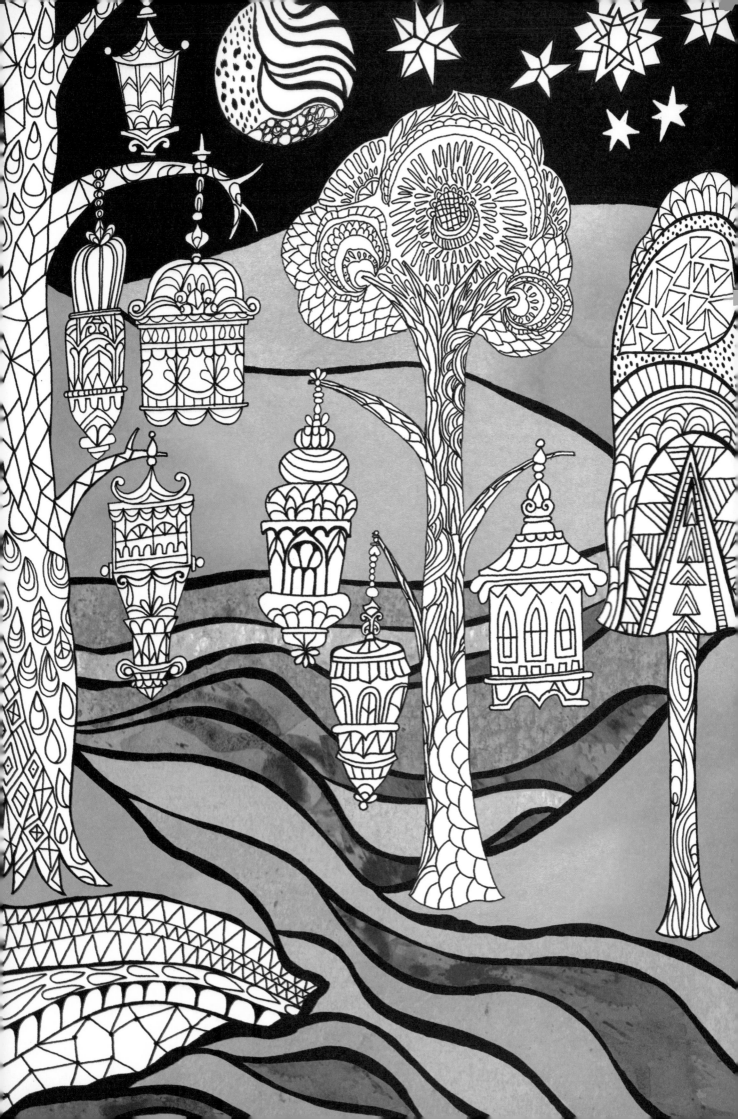

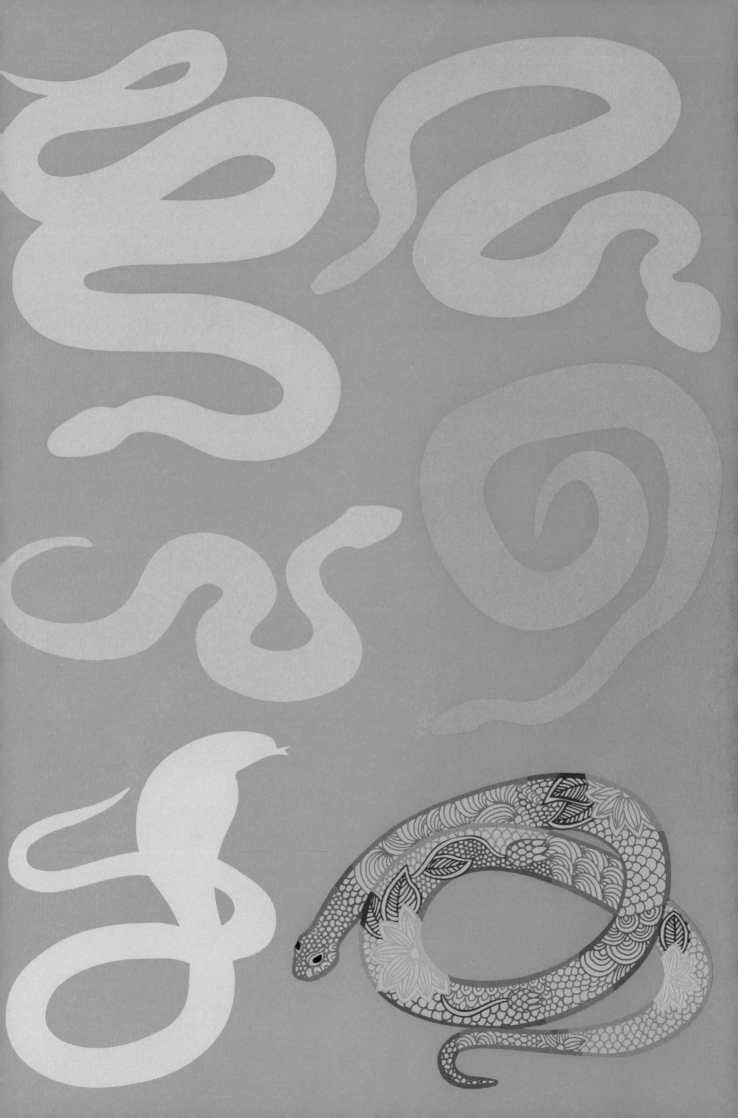

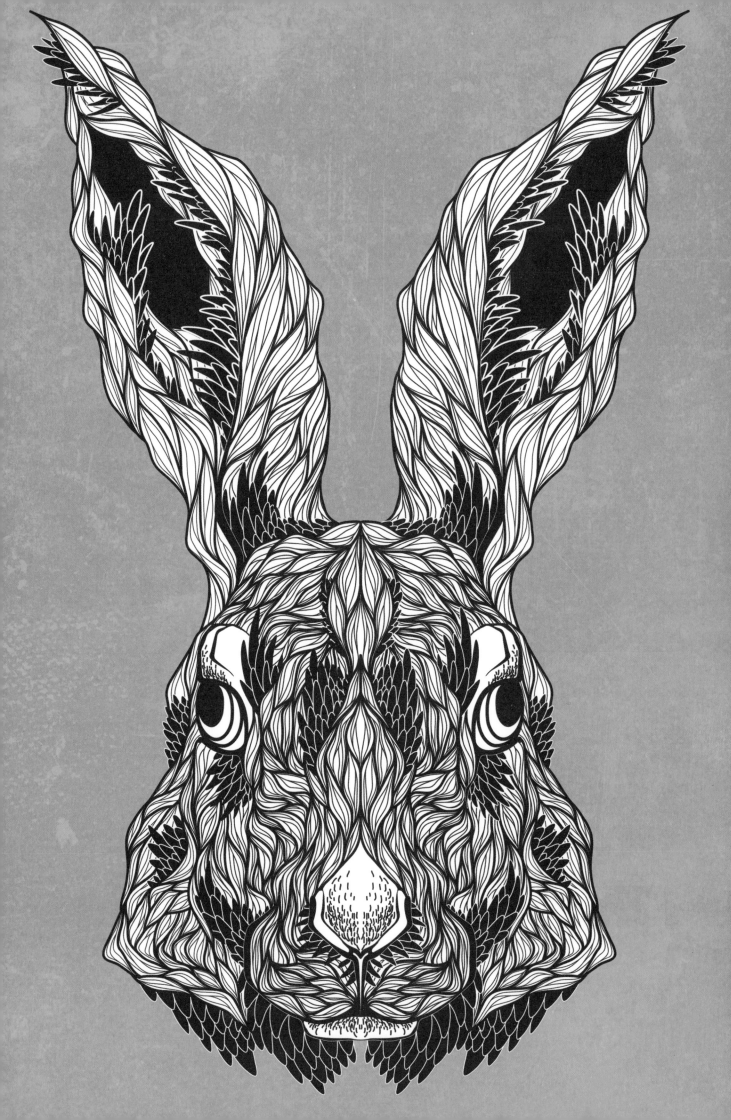

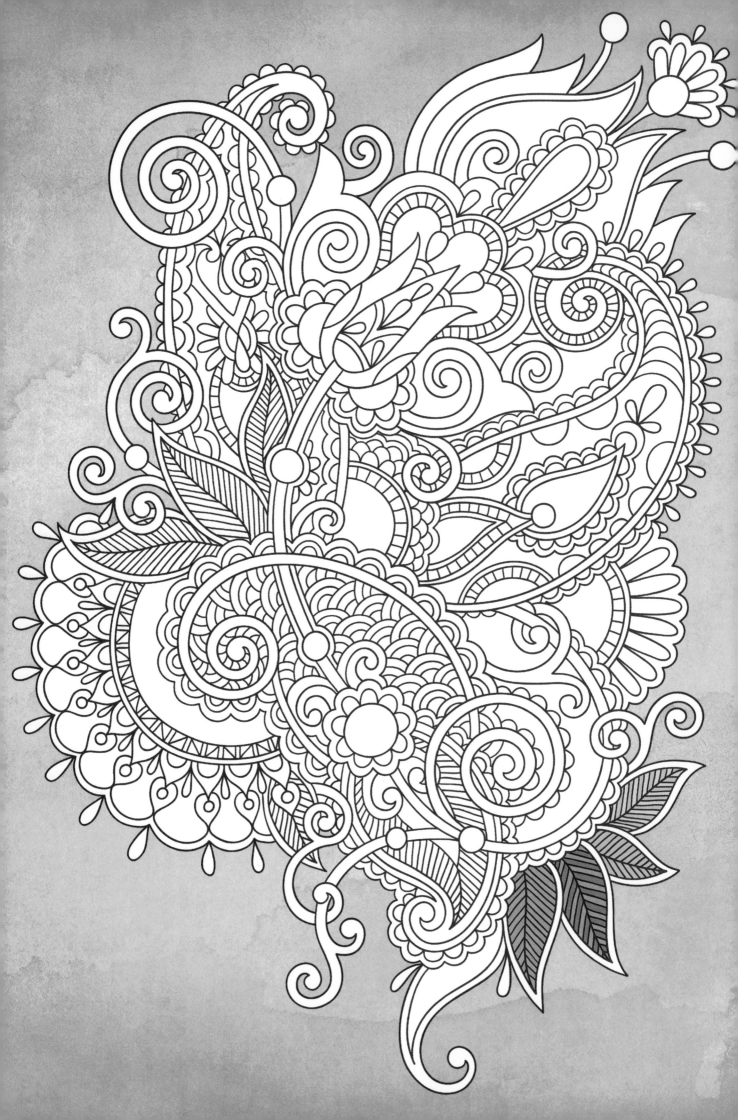

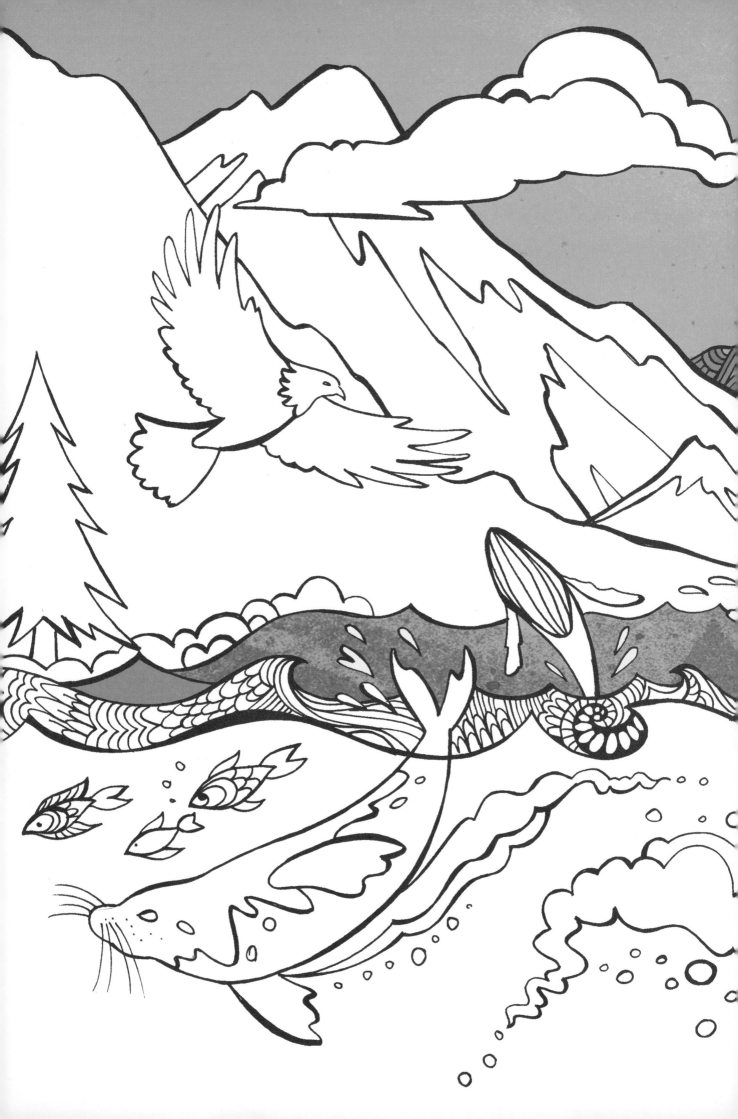

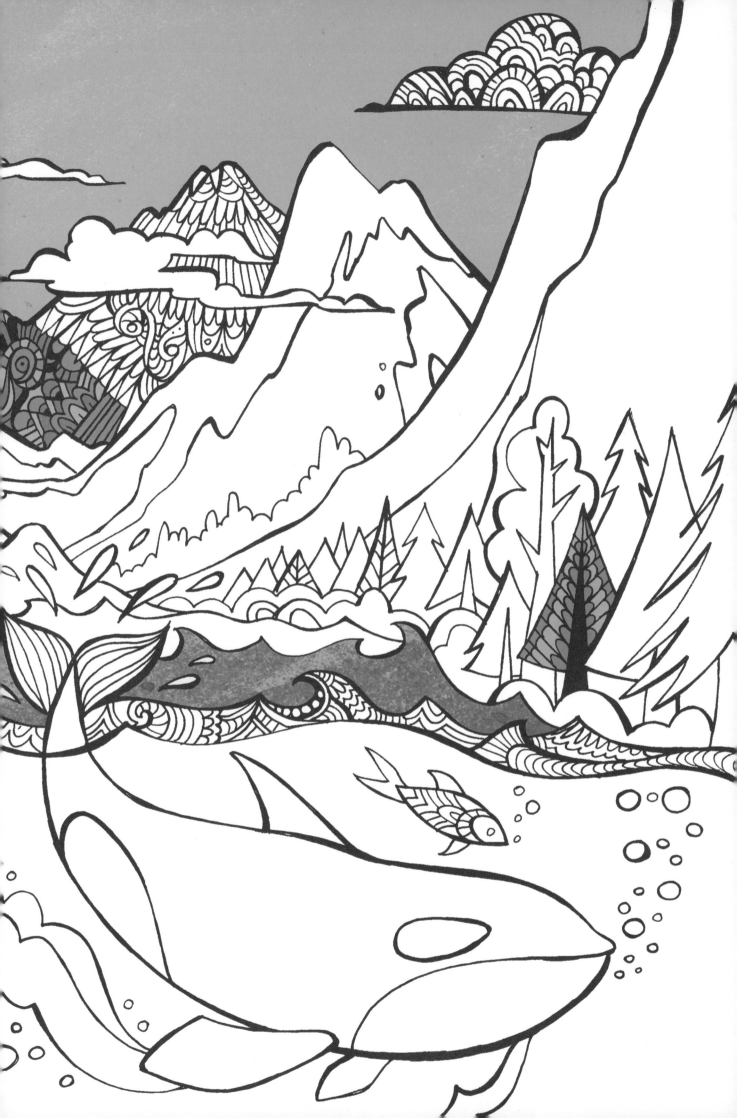

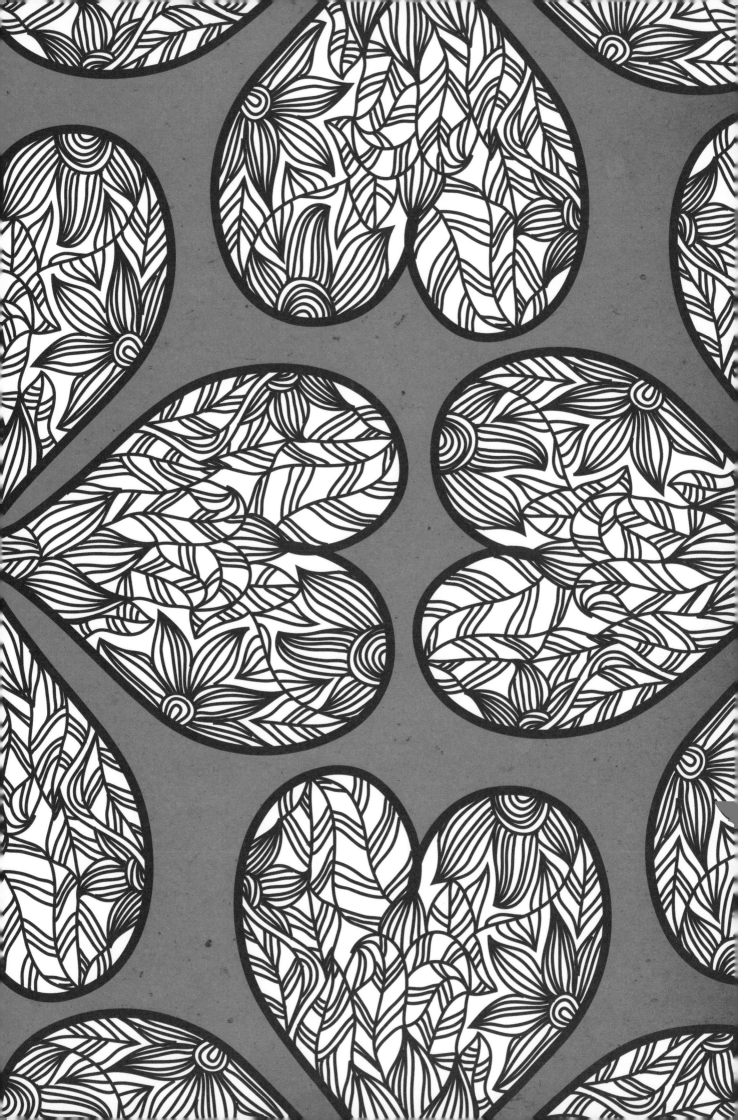

BLUE

From bright-blue skies on a sunny day to the cool, icy blues of winter, the ultramarine depths of the ocean and the azure of a sapphire, blue can be both calm and relaxing or deep and mysterious.

COMPLEMENTARY COLOUR:

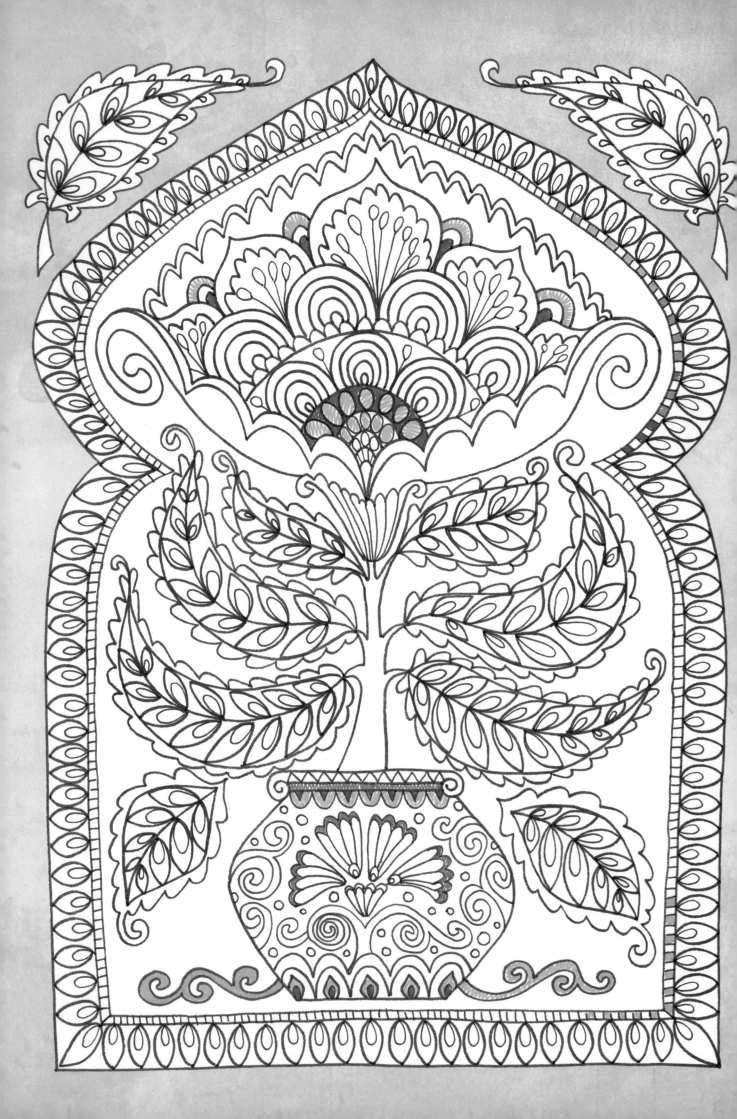

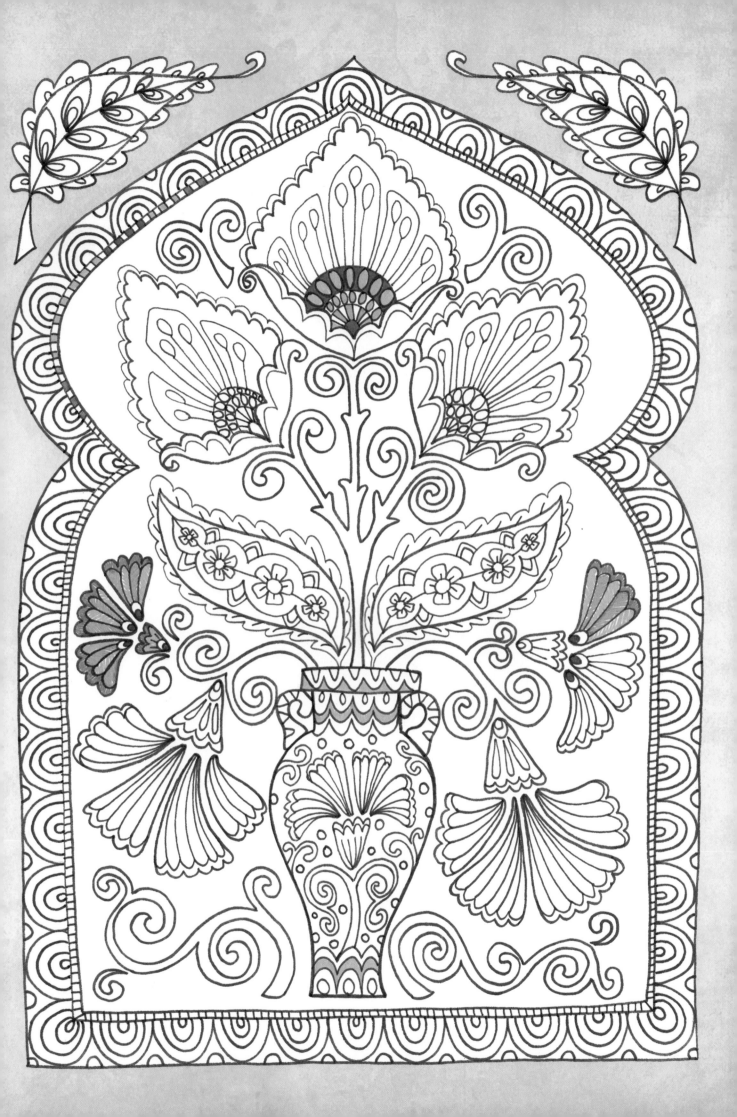

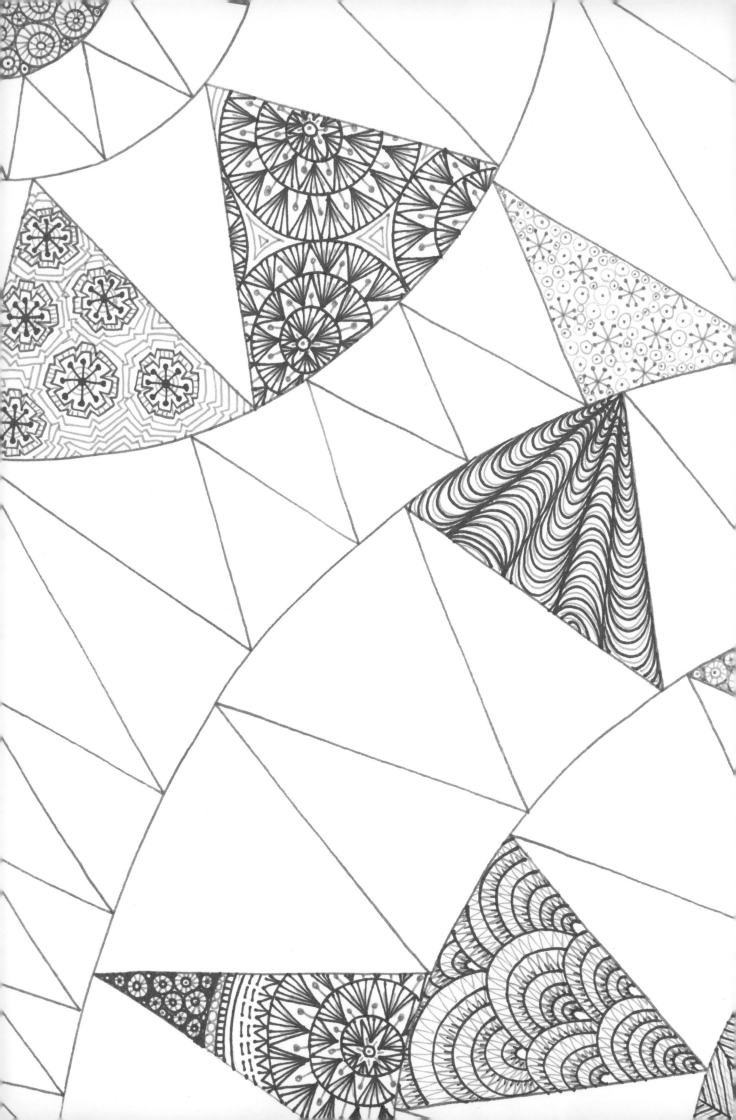

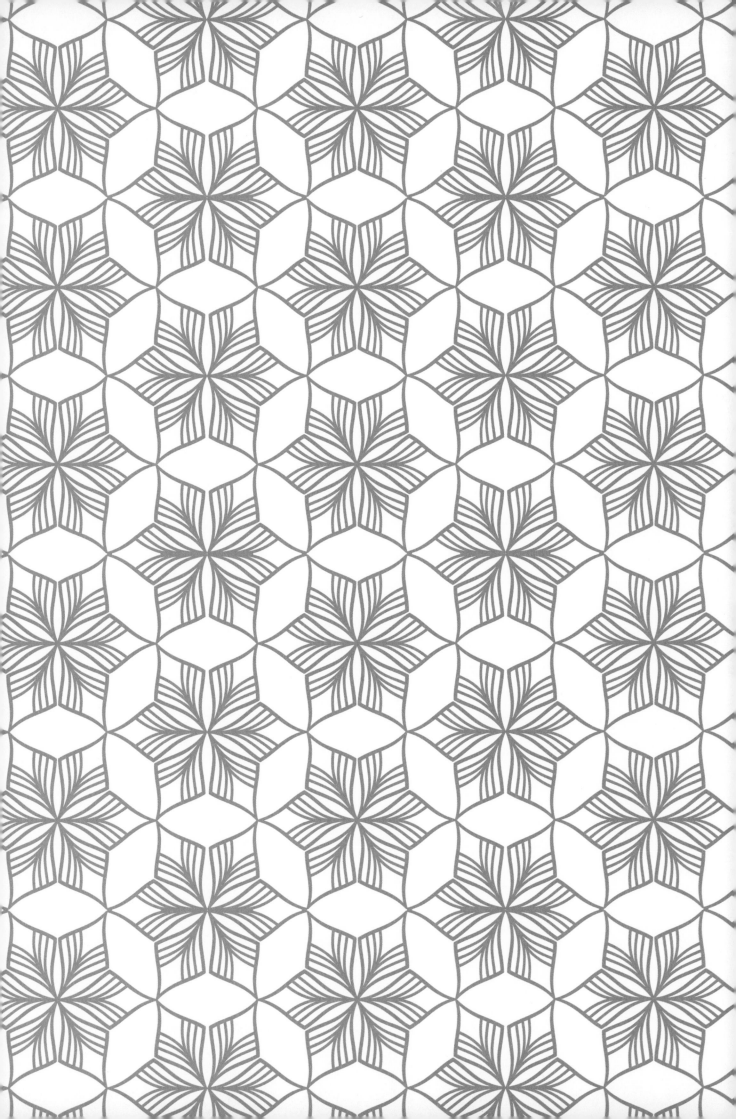

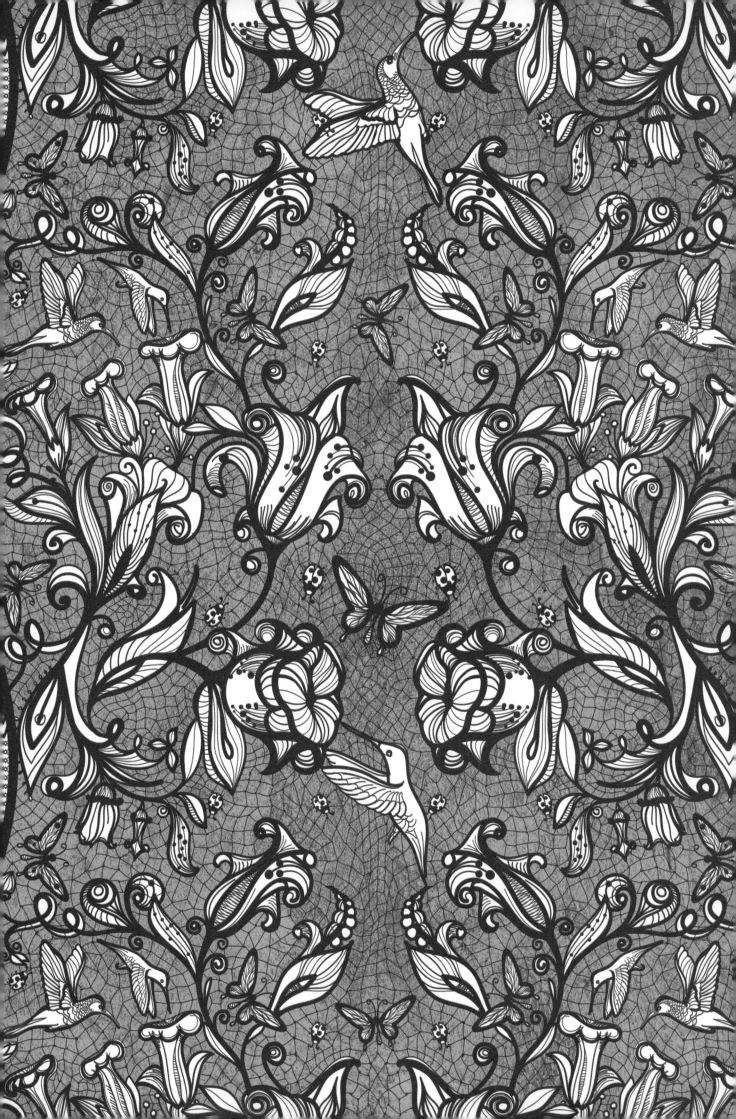

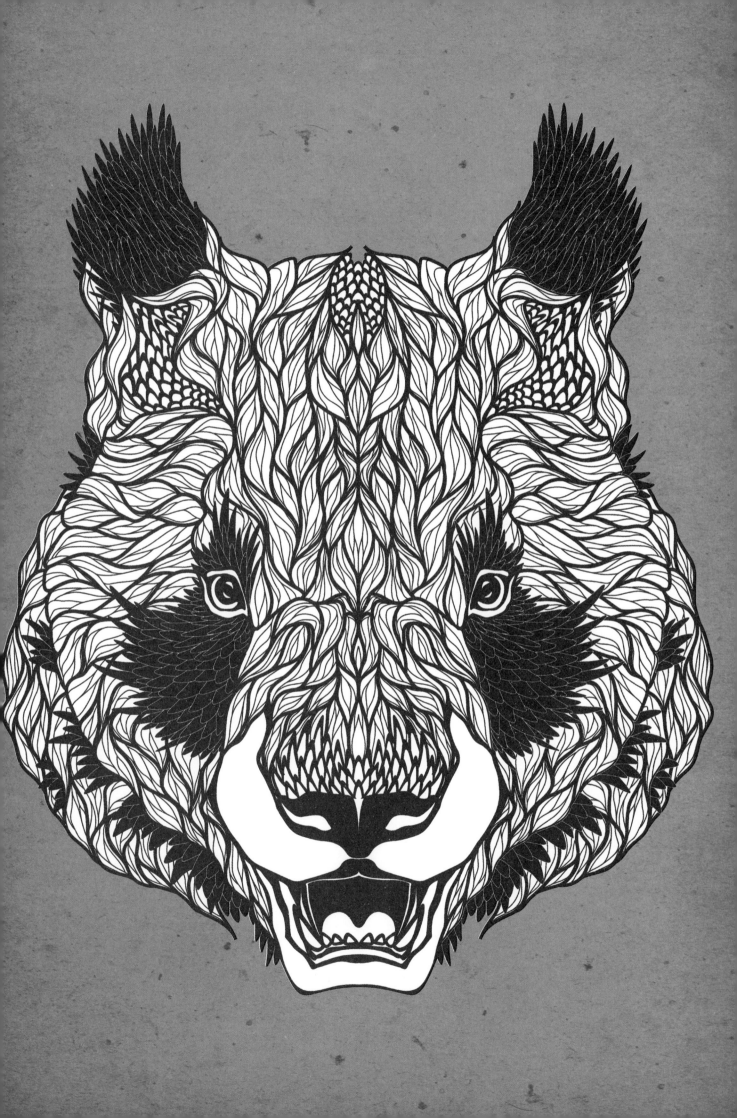

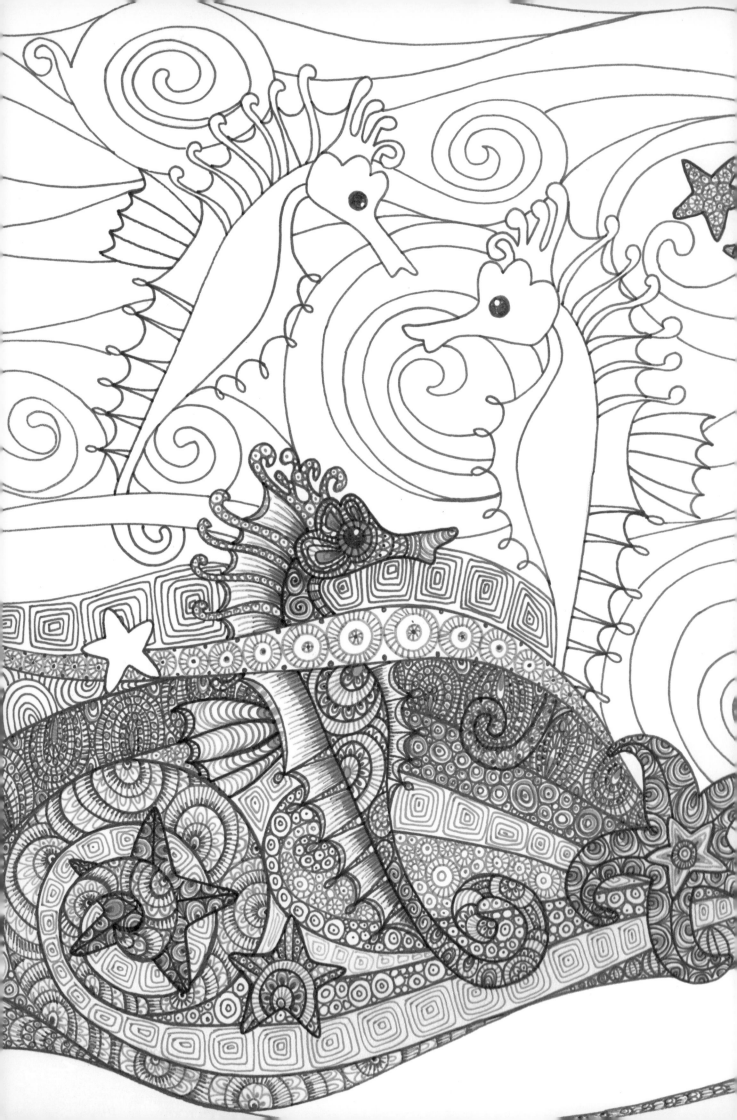

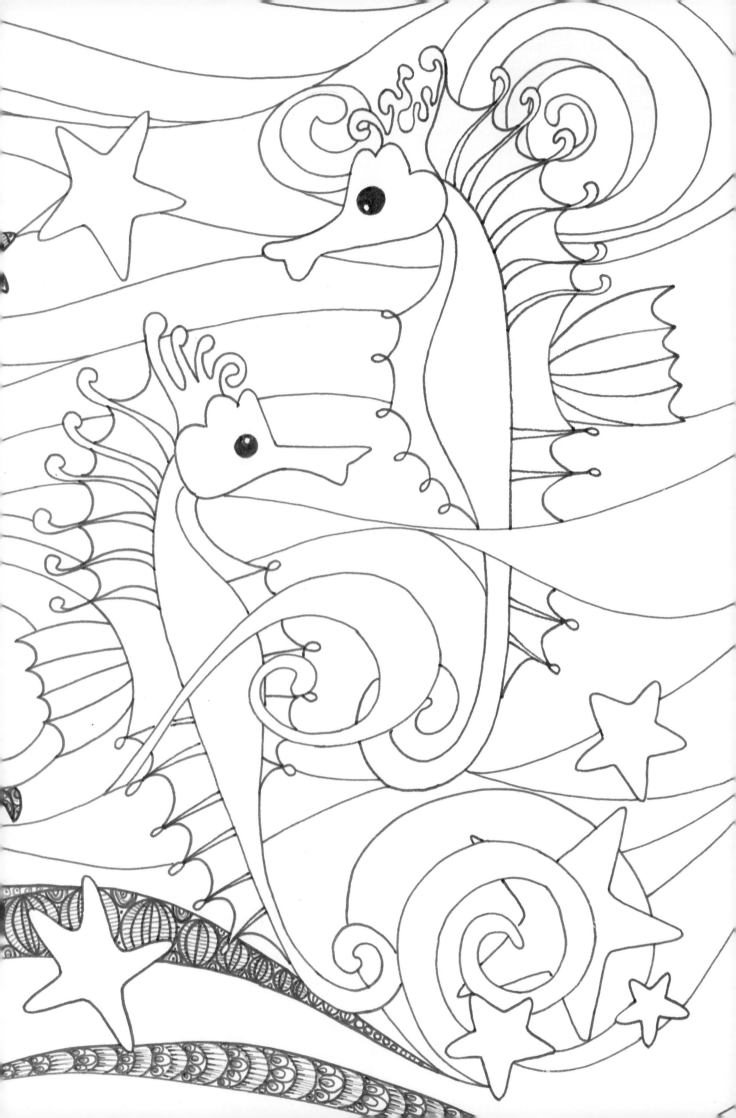

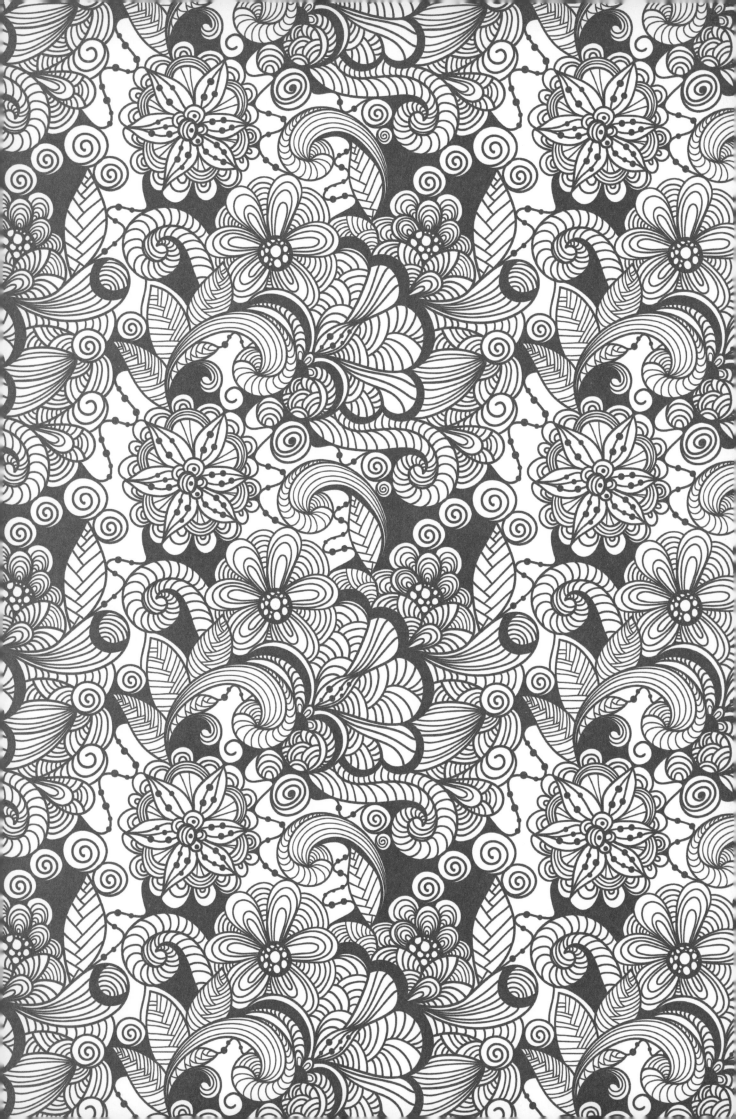

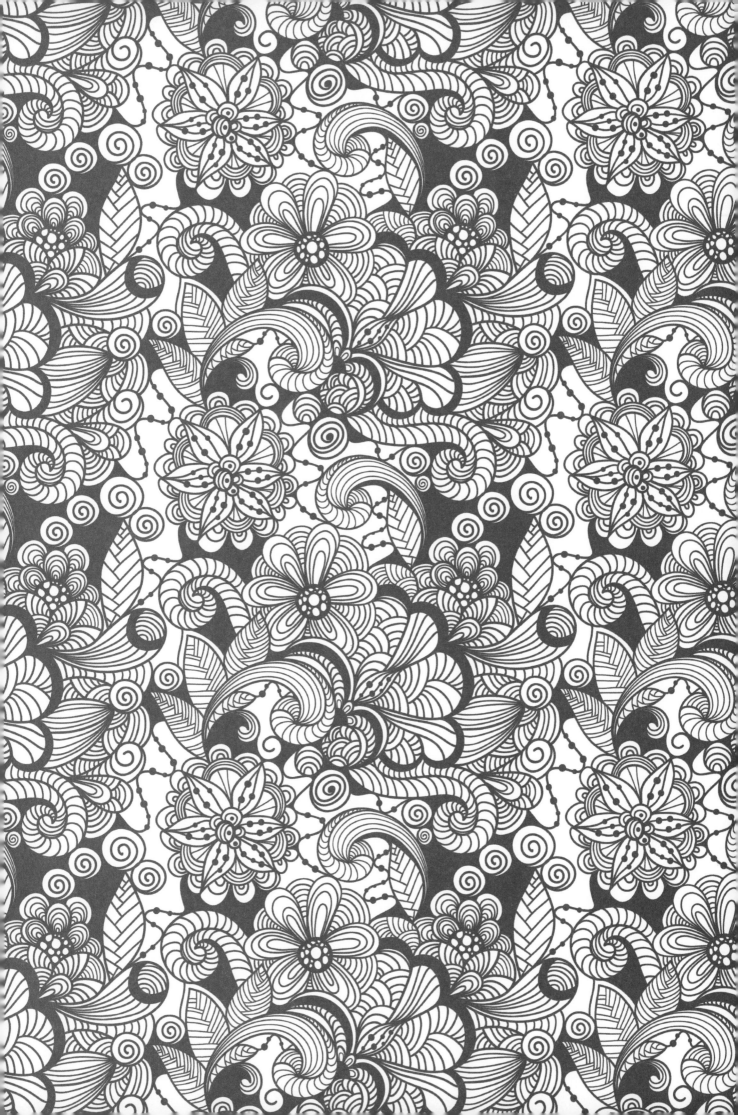

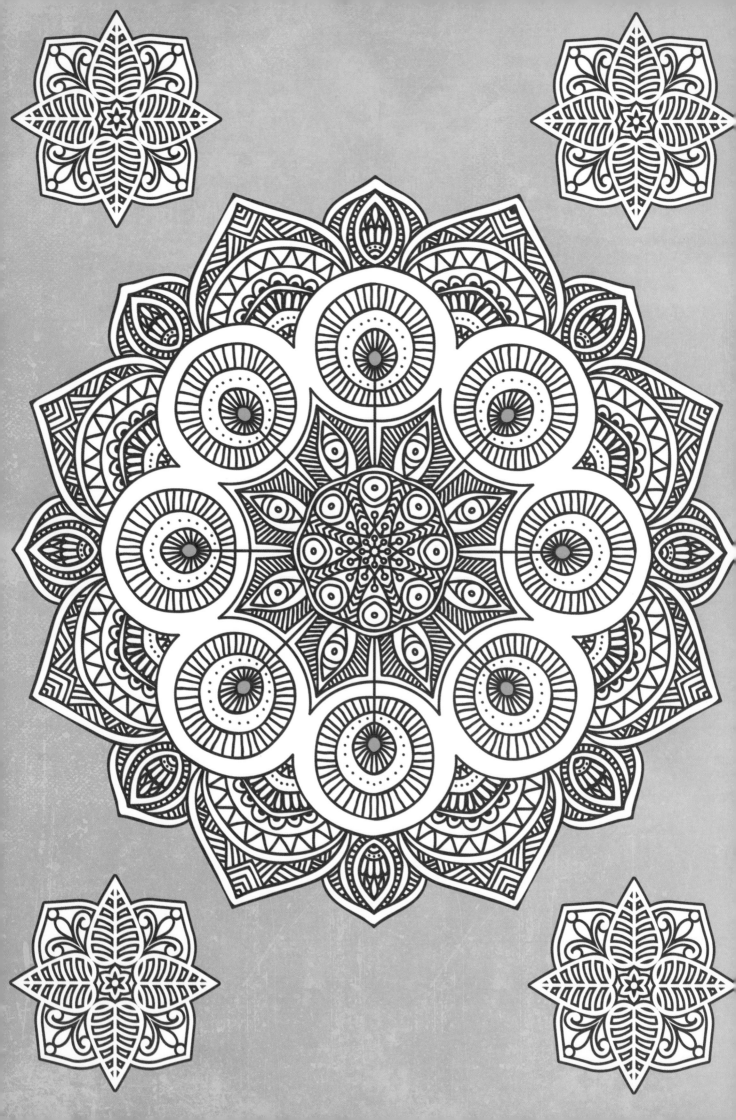

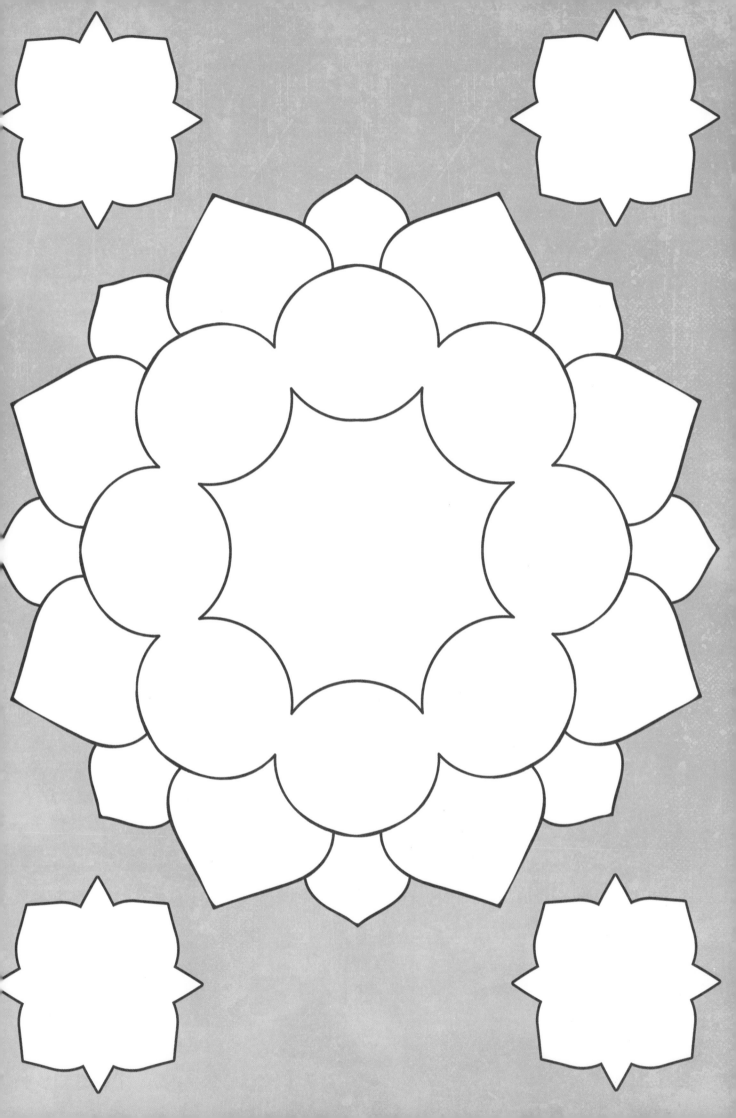

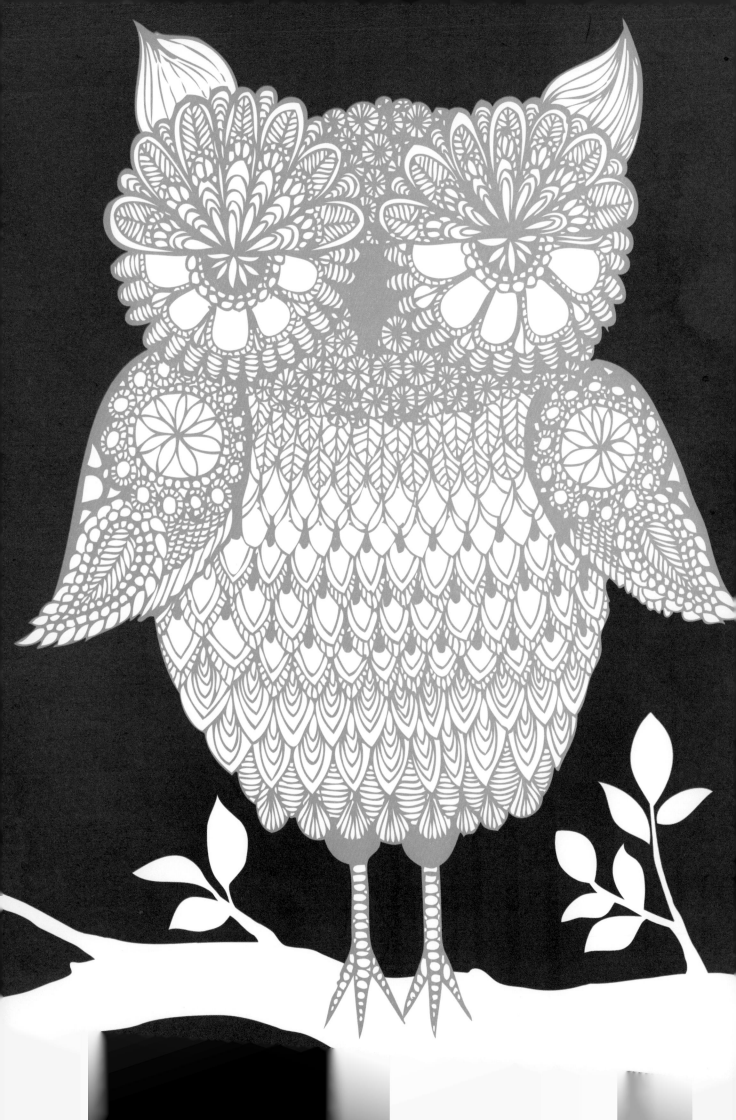

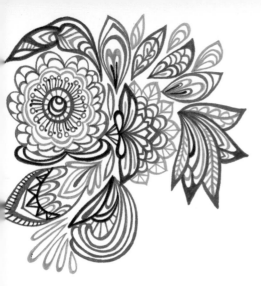
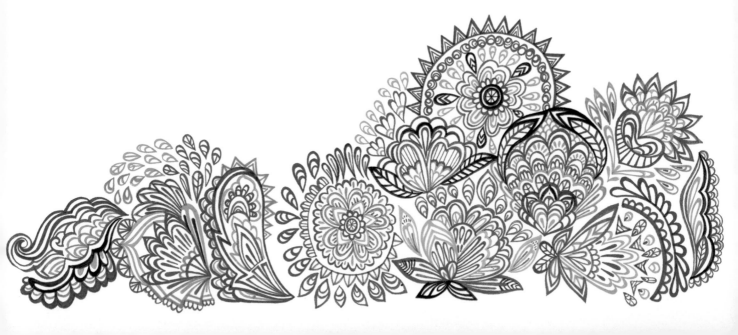

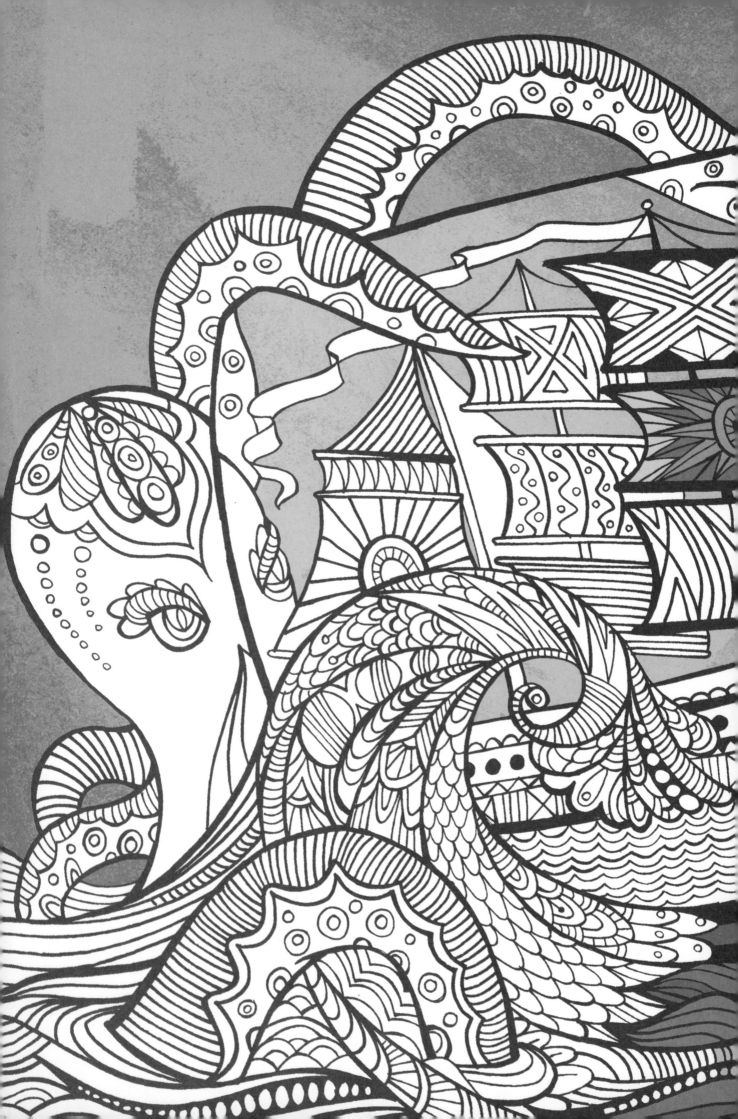

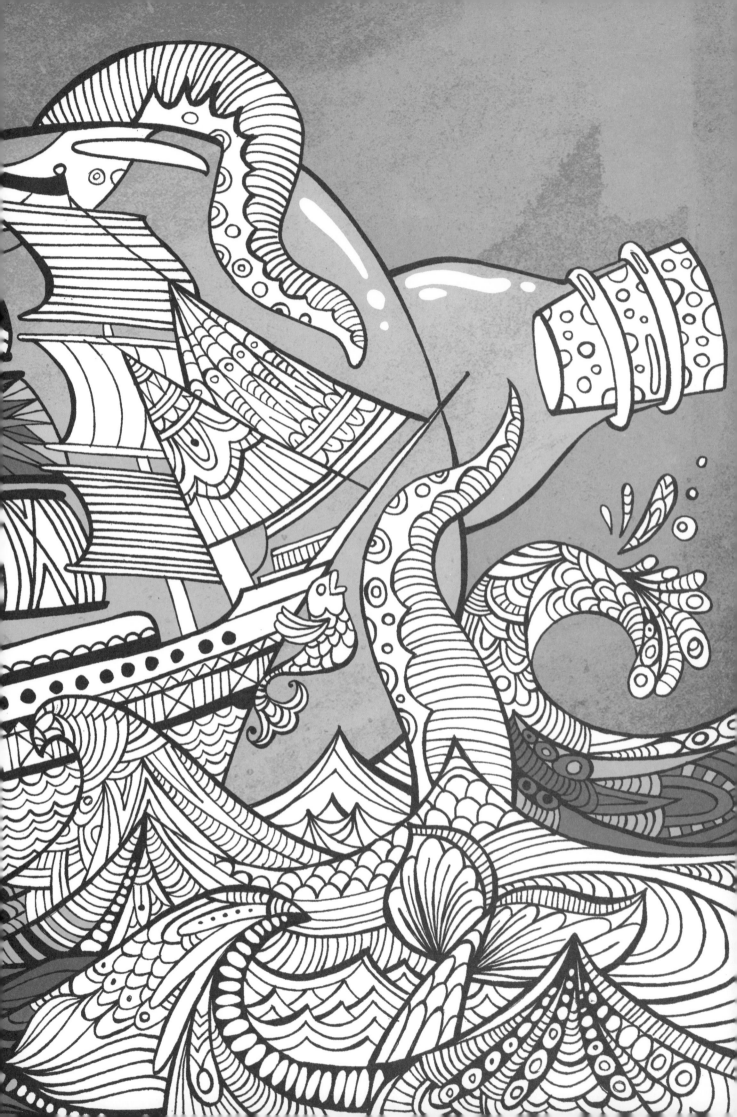

INDIGO & VIOLET

Indigo and violet are luxurious colours.
From delicate flowers and beautiful butterflies
to bruised stormy skies, the rich and intensifying
tones of these colours are sensual and soothing.

COMPLEMENTARY COLOUR:
YELLOW

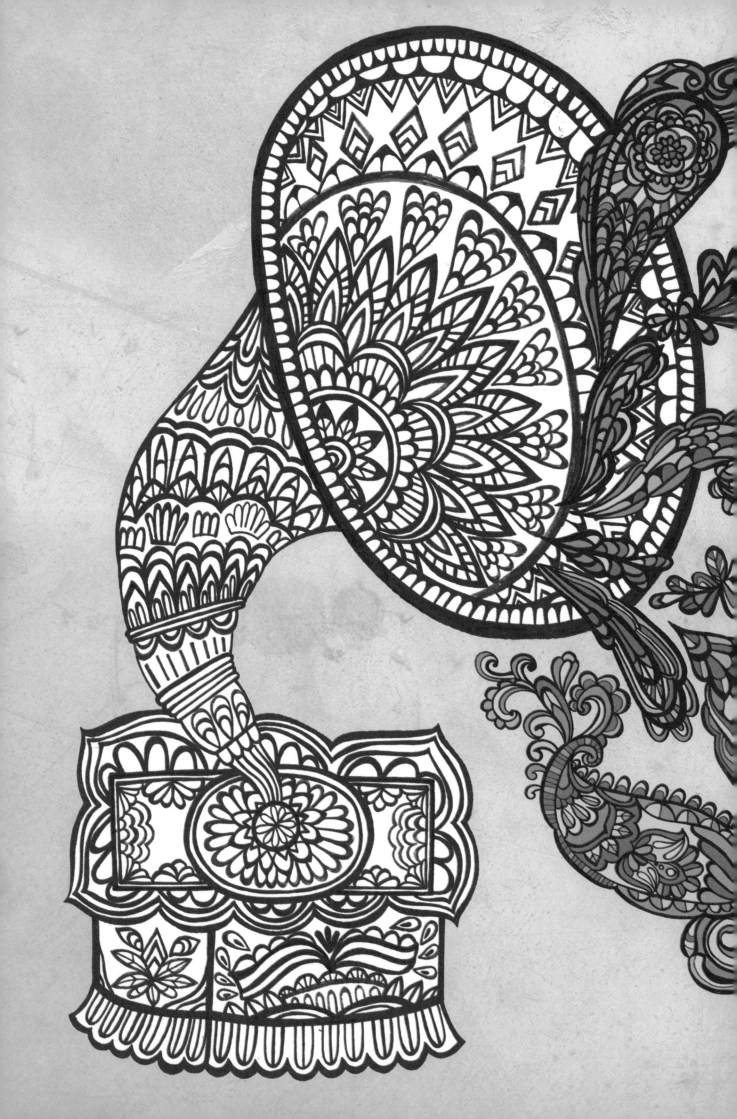

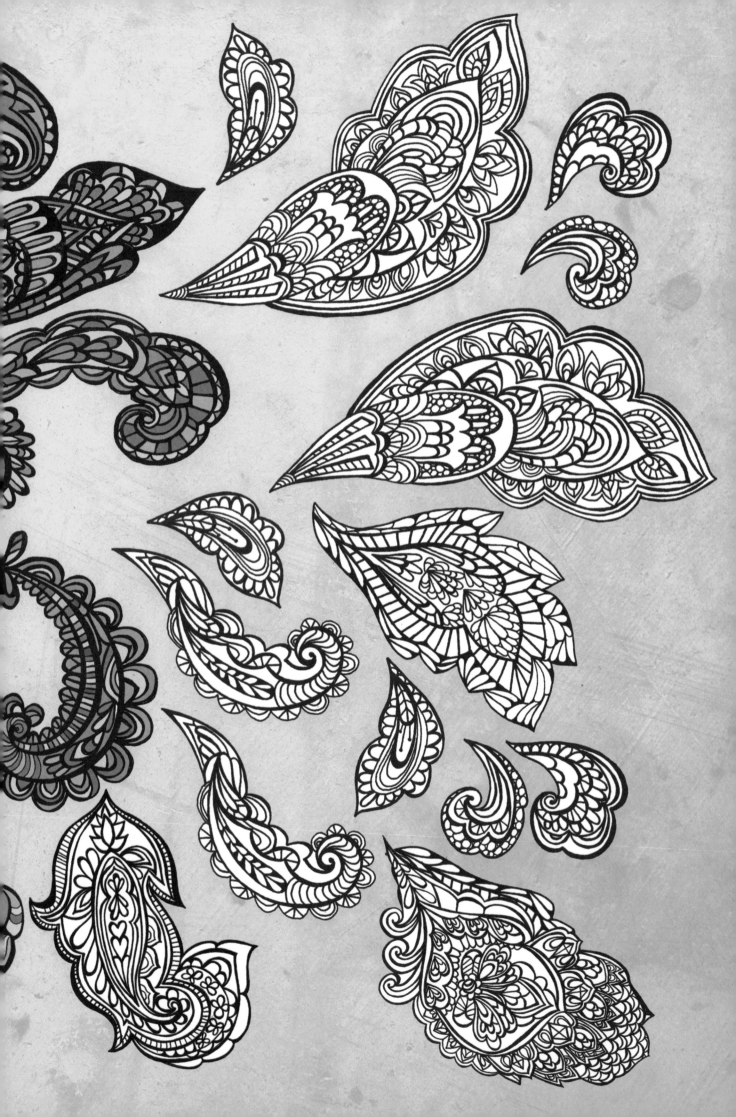

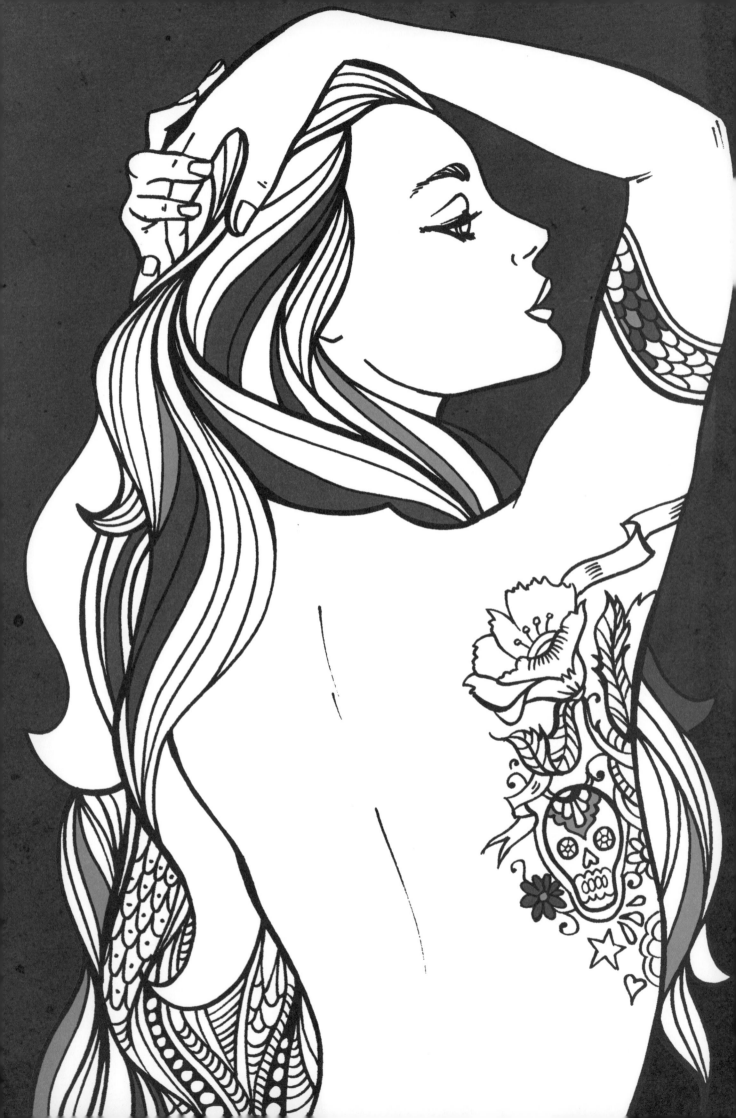

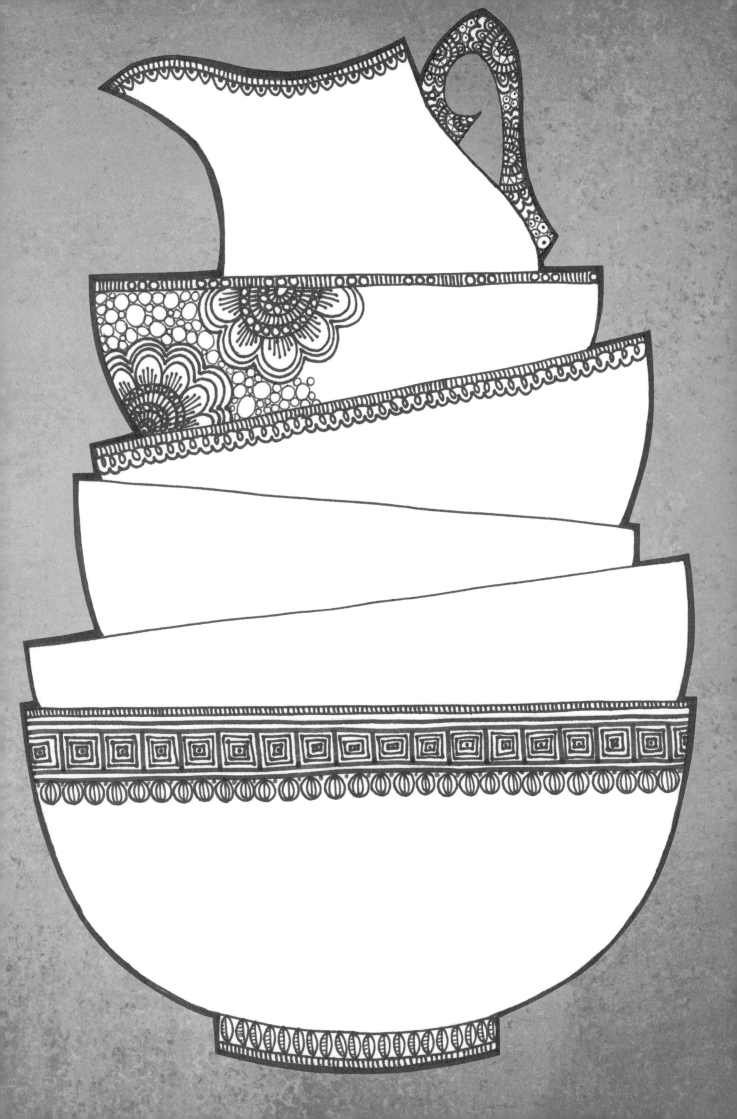

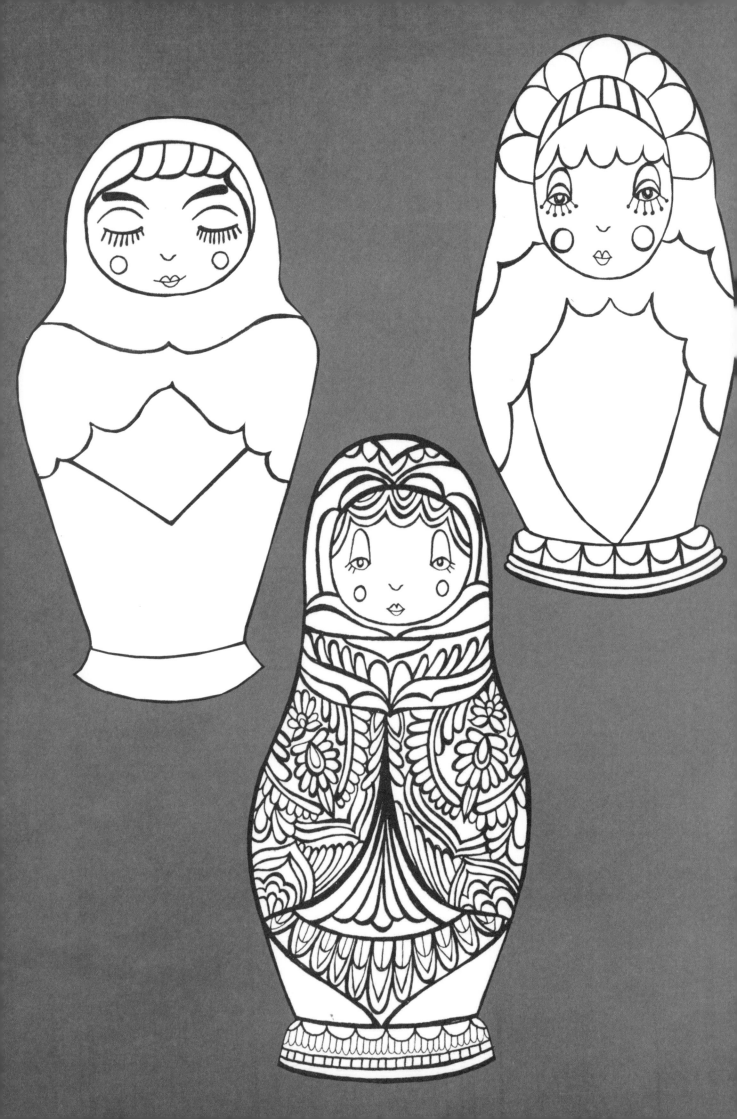

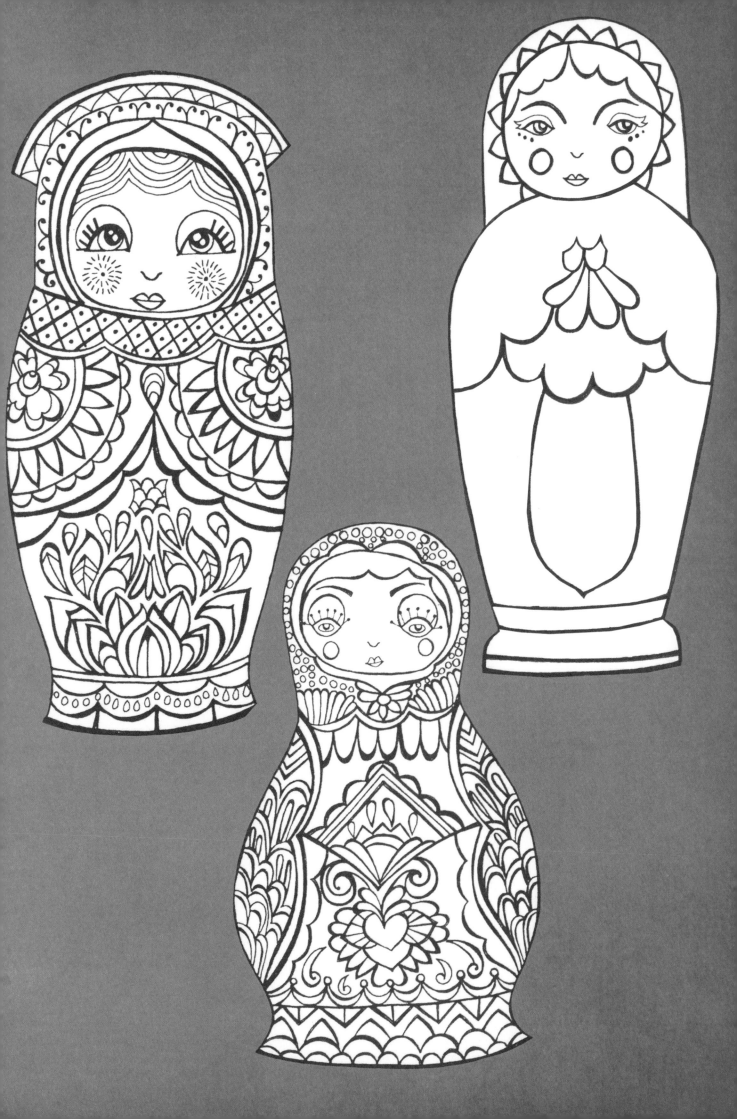

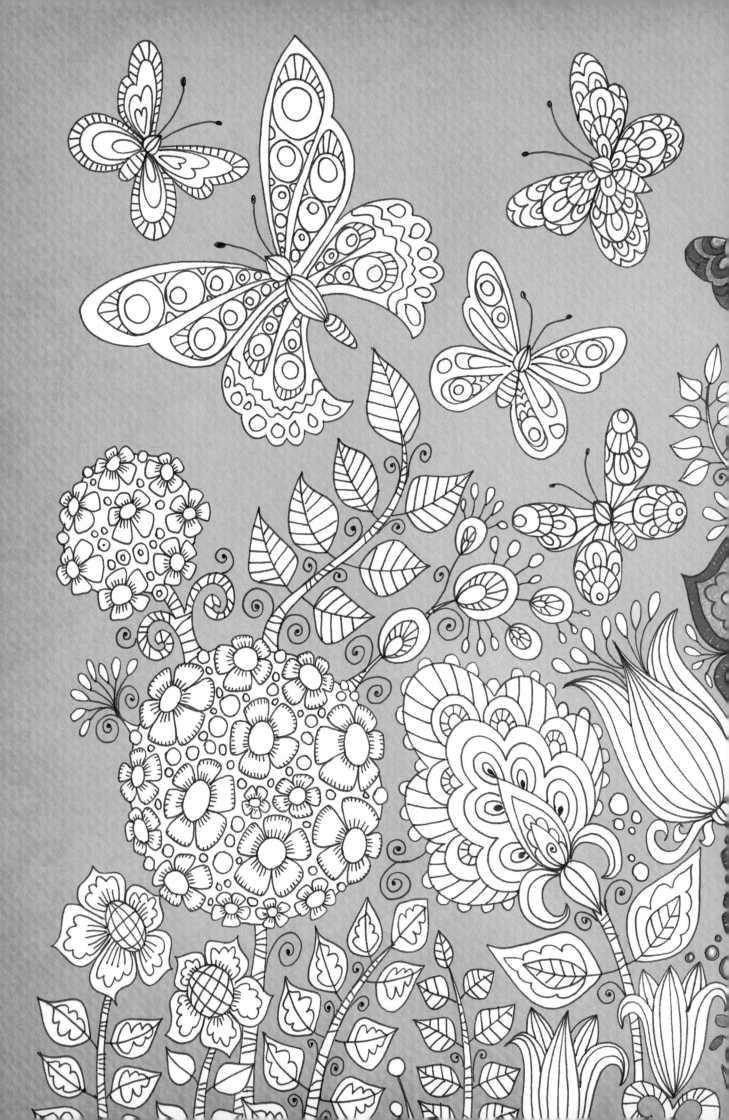

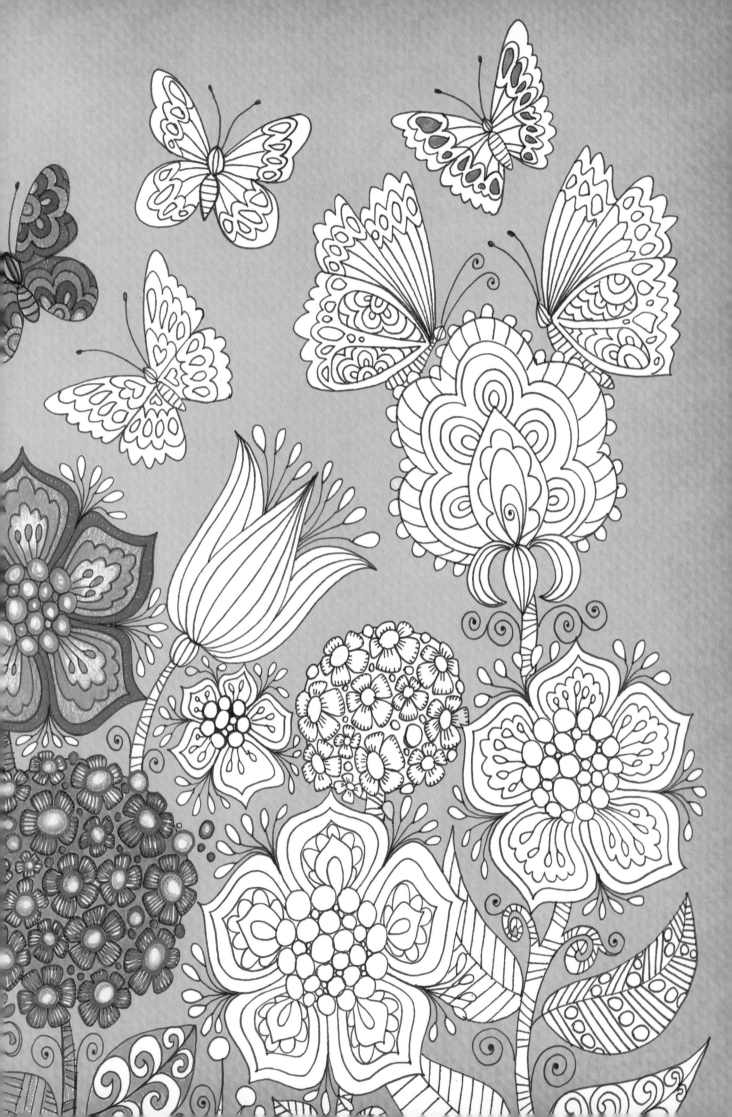

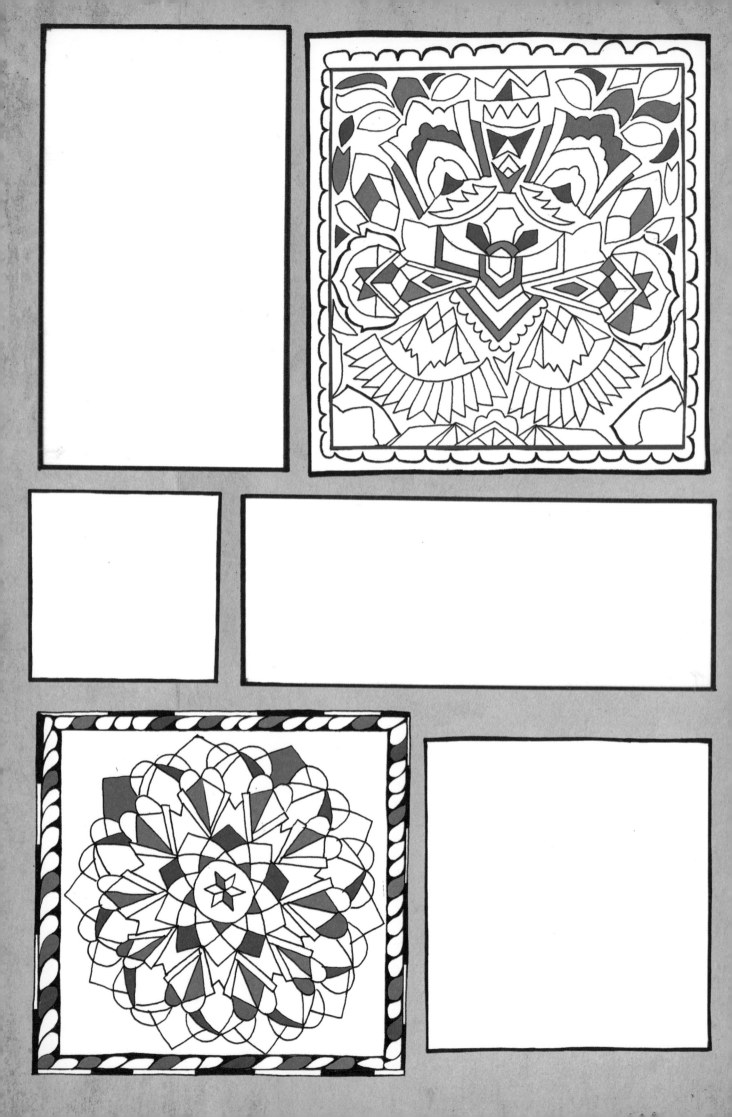

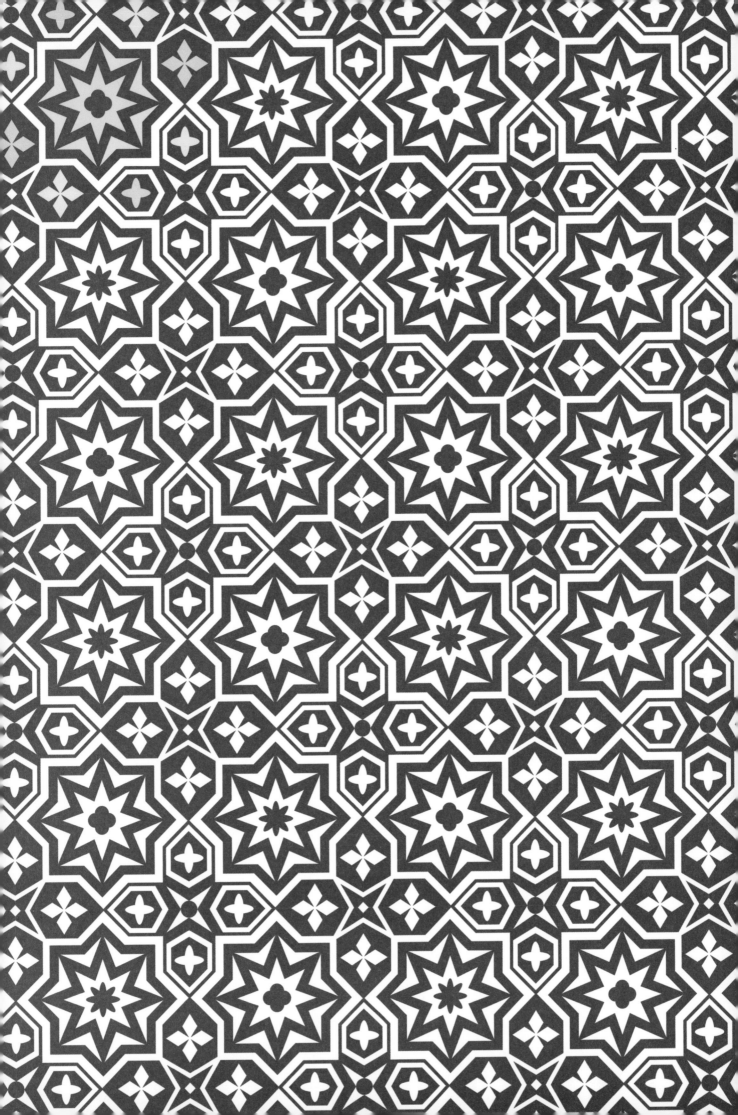

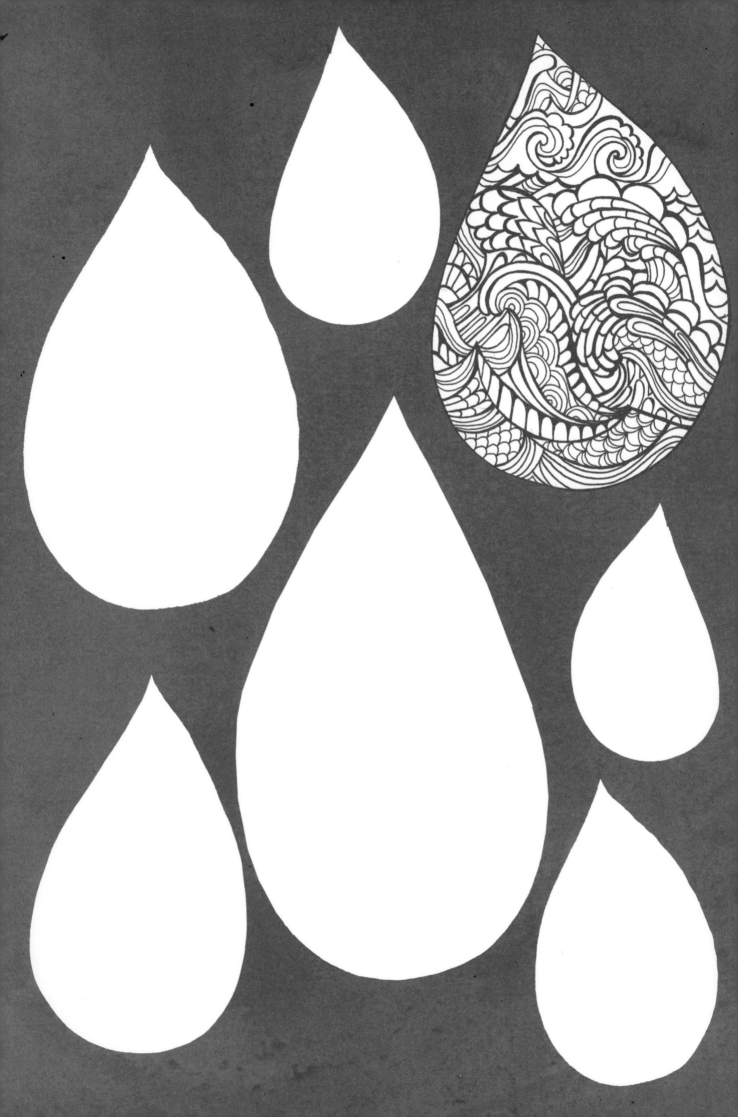

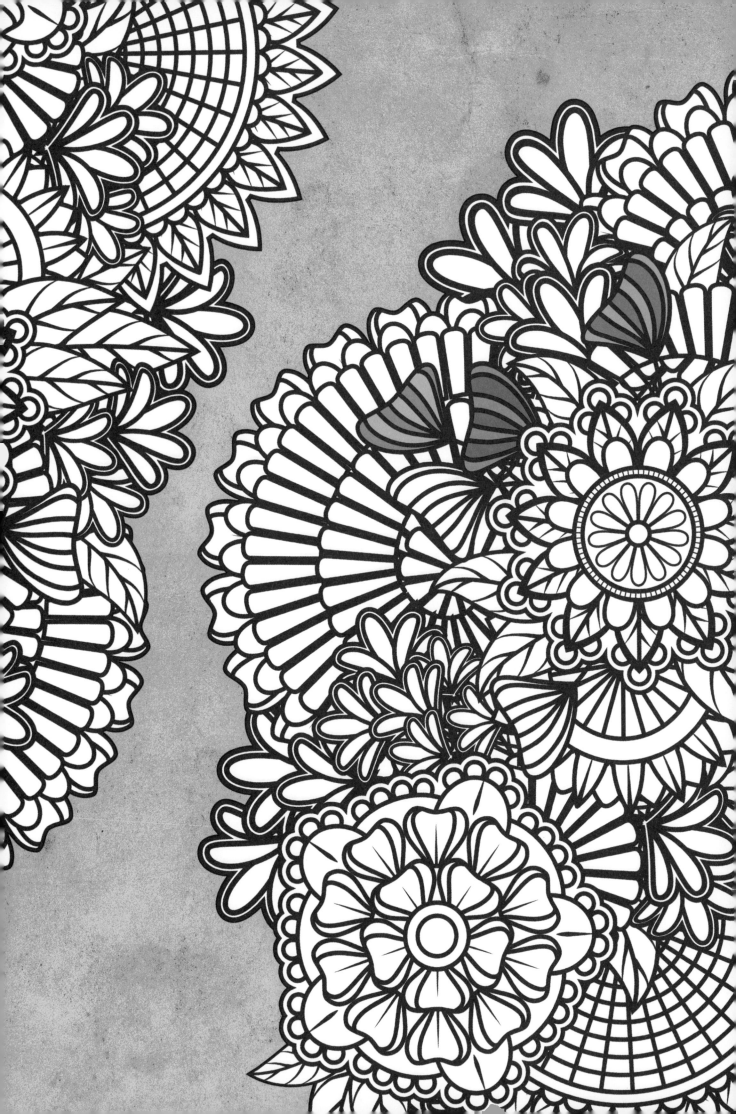

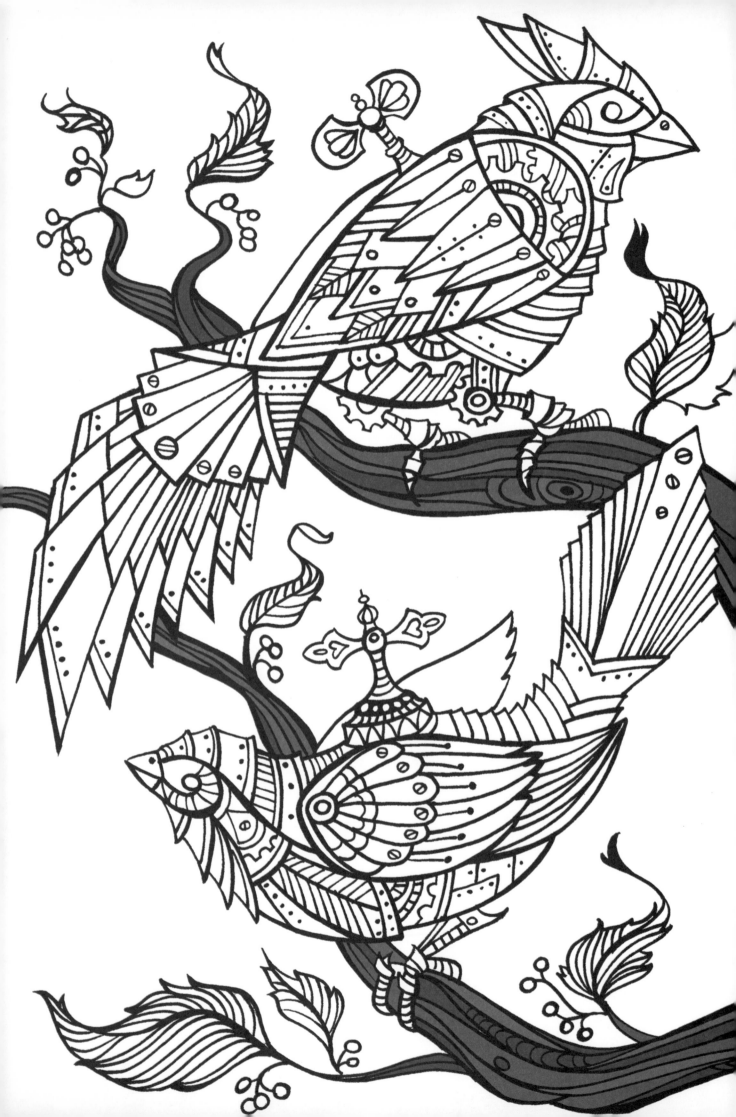

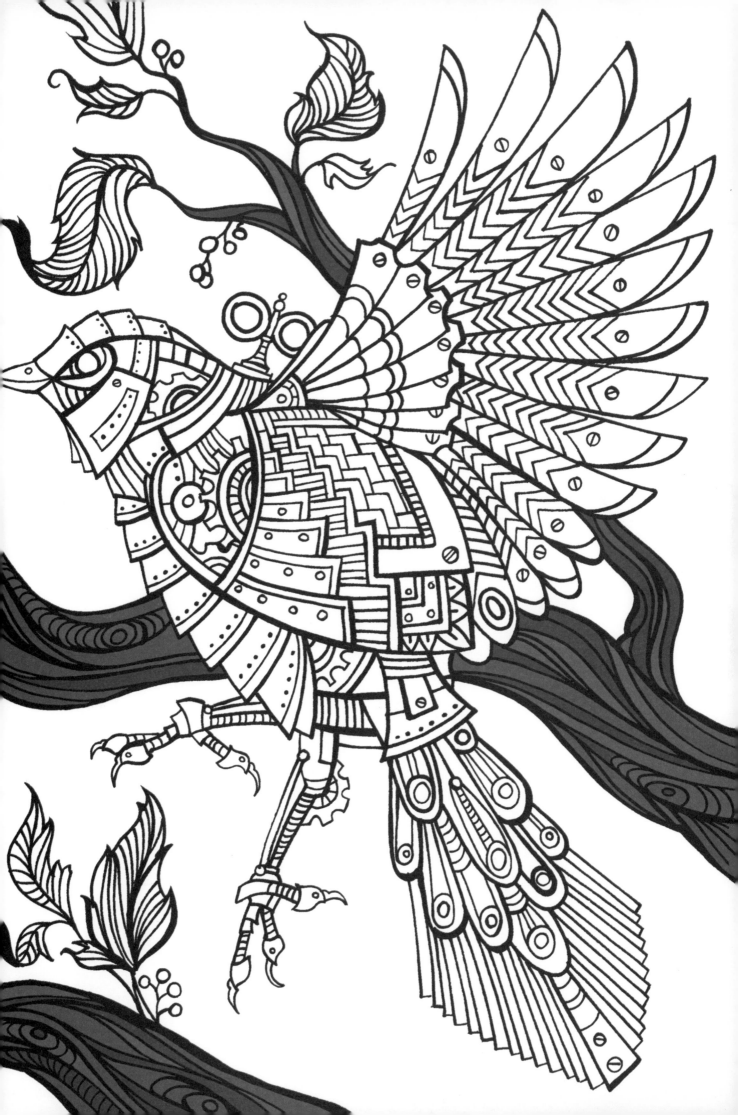

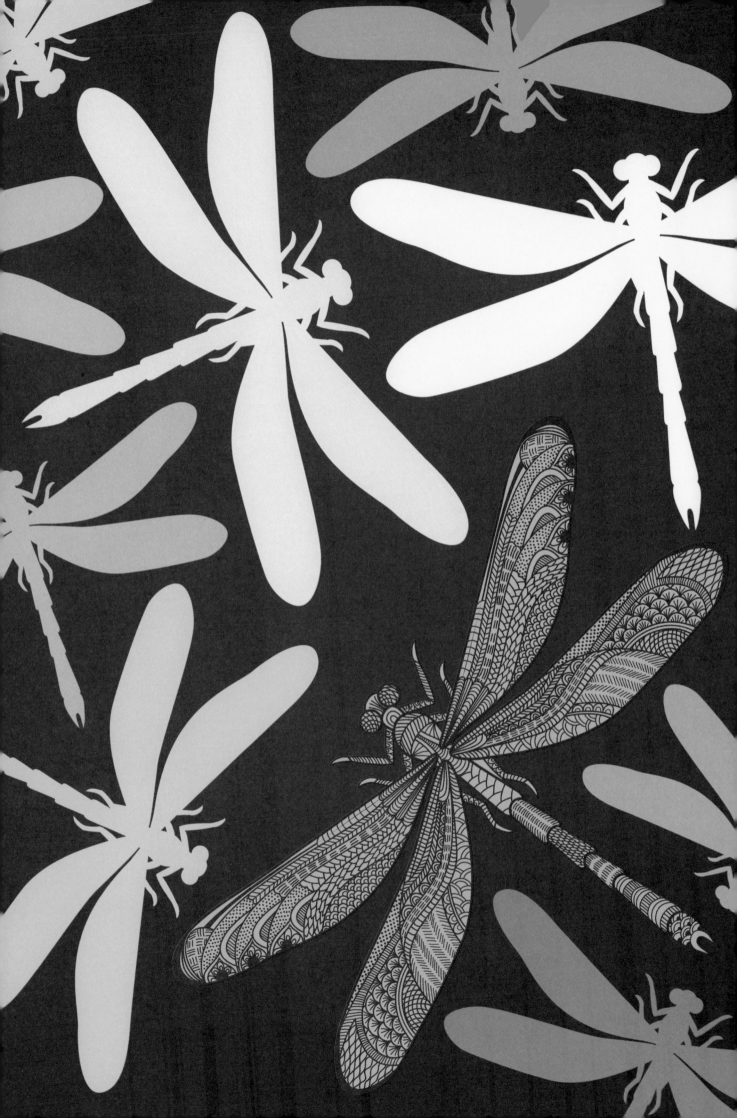

PINK

Pink is the colour of delicate blossoms and flamboyant flamingos. It is a smooth and romantic colour but it can also be hot and electric.

COMPLEMENTARY COLOUR:

GREEN

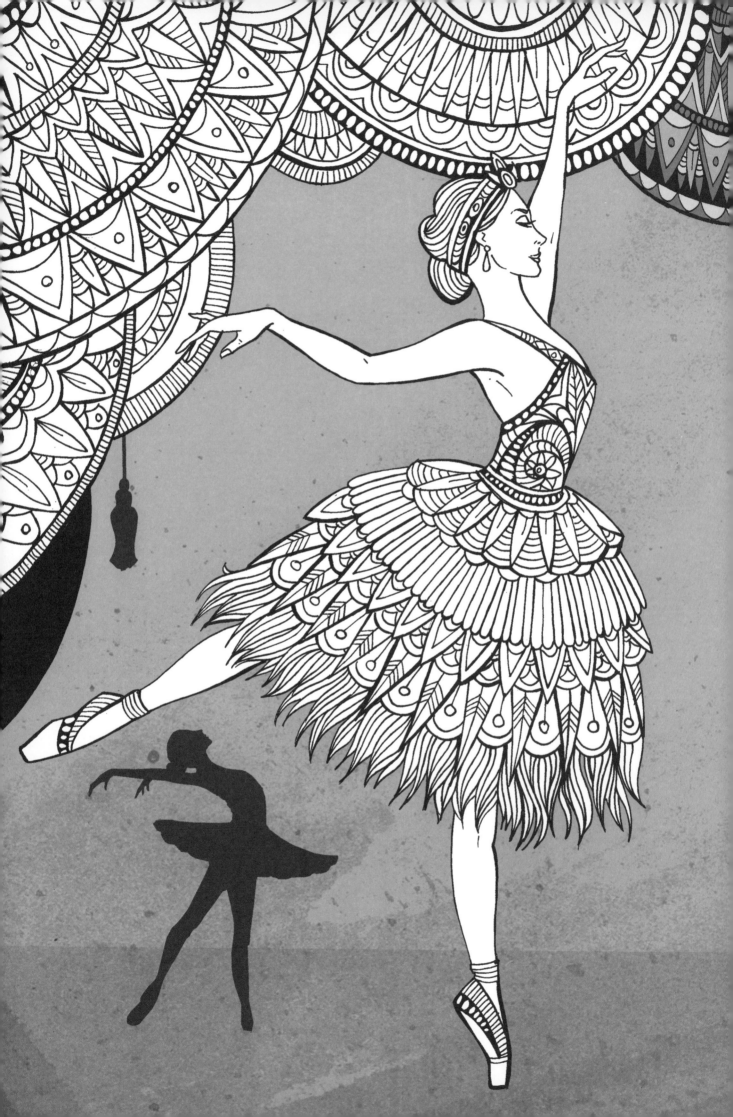

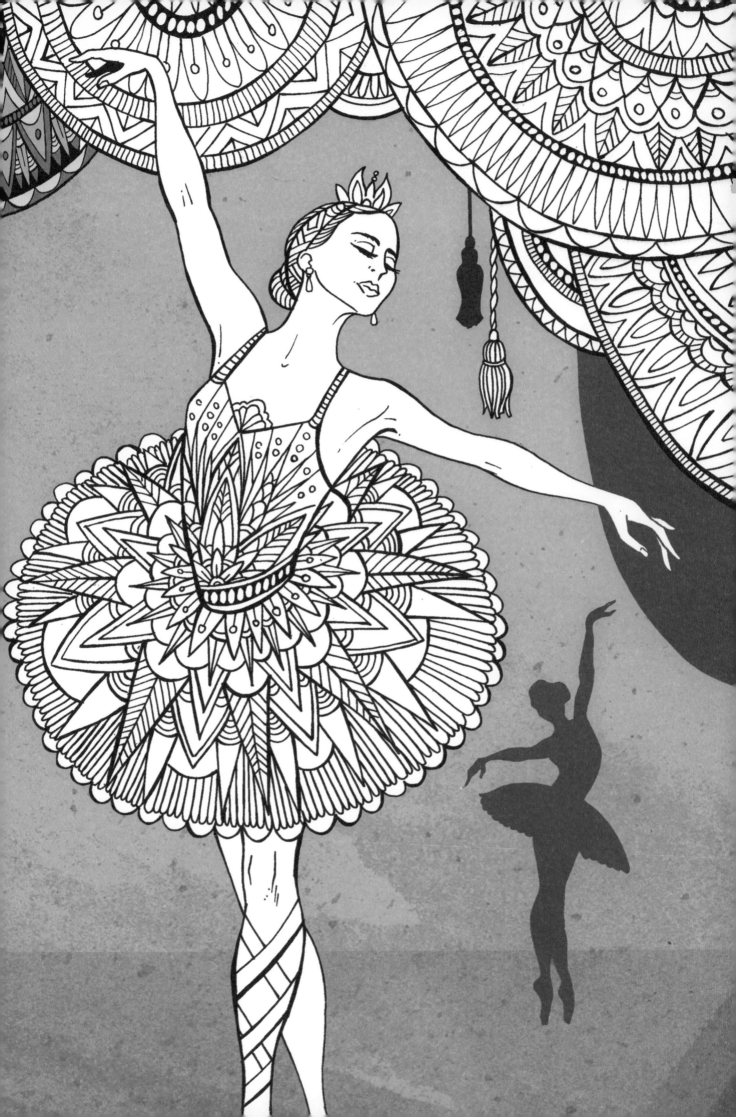

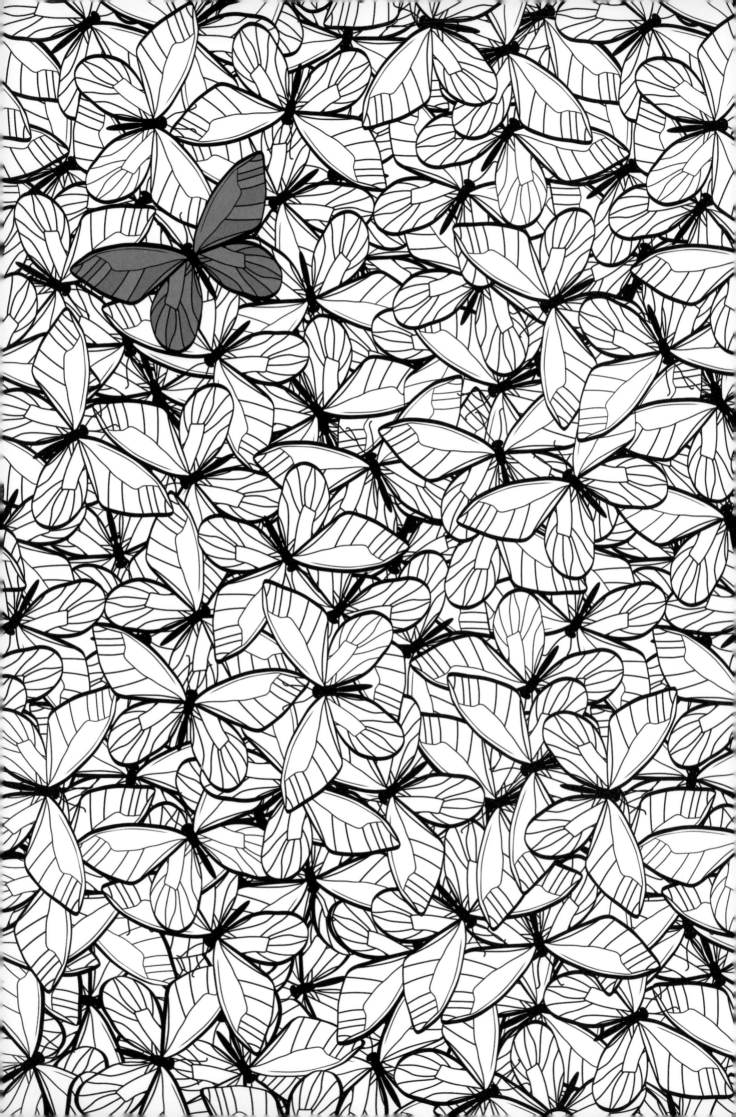

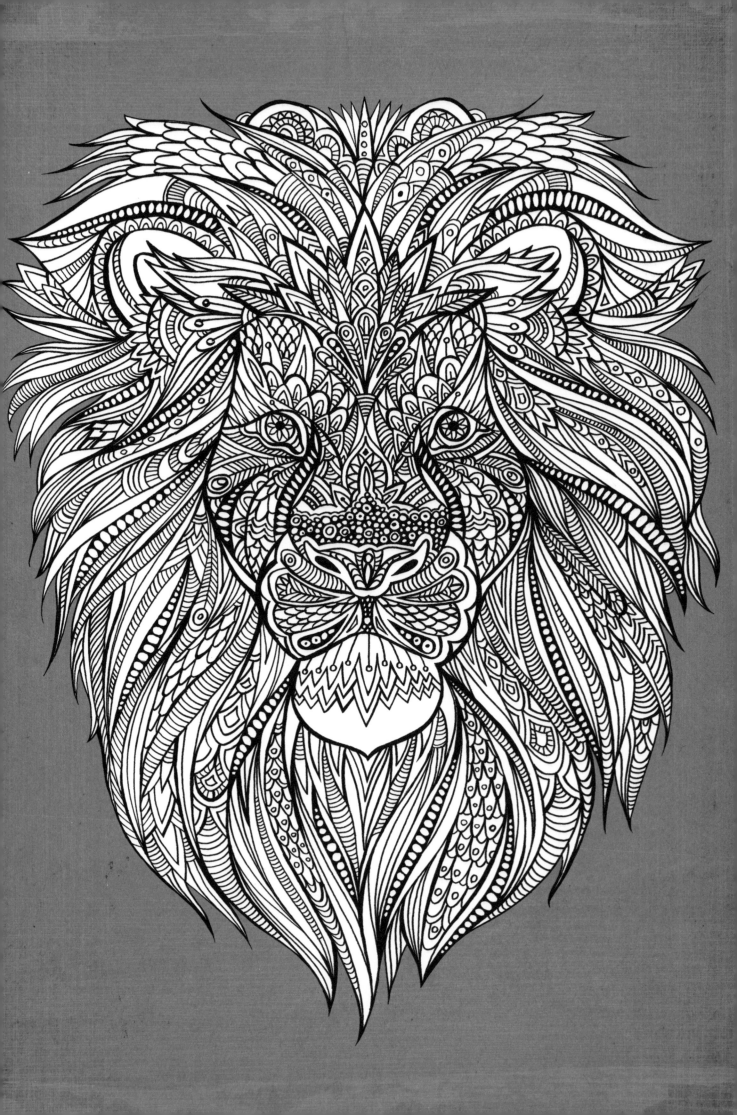

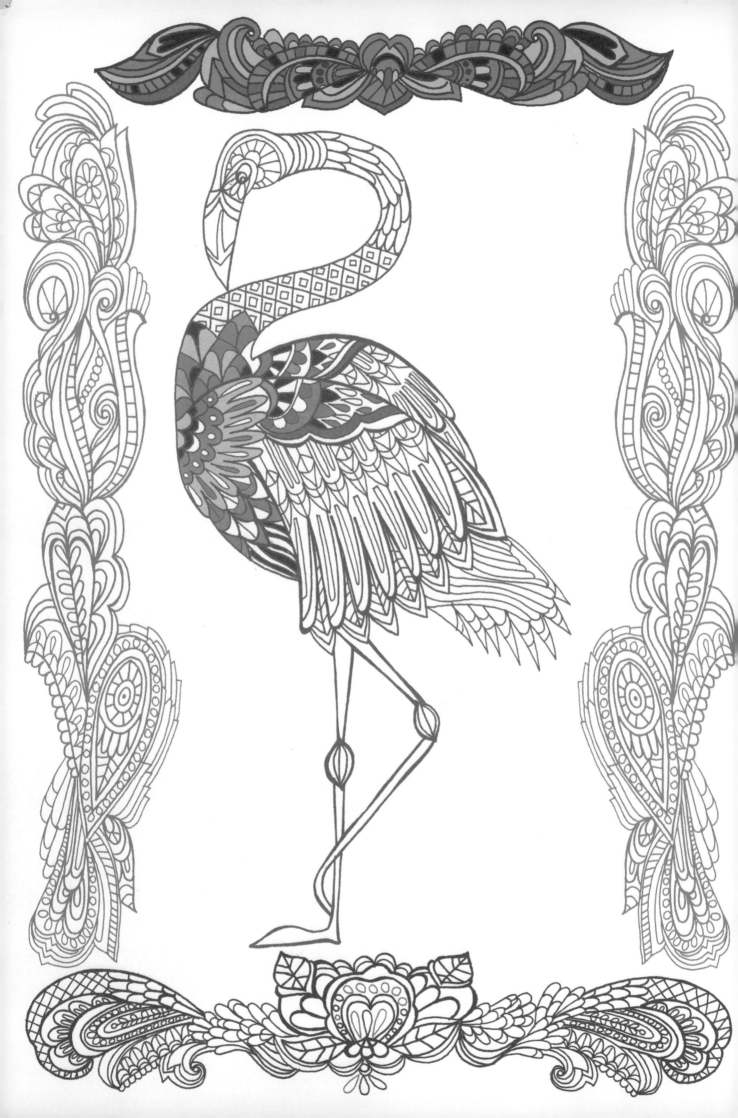

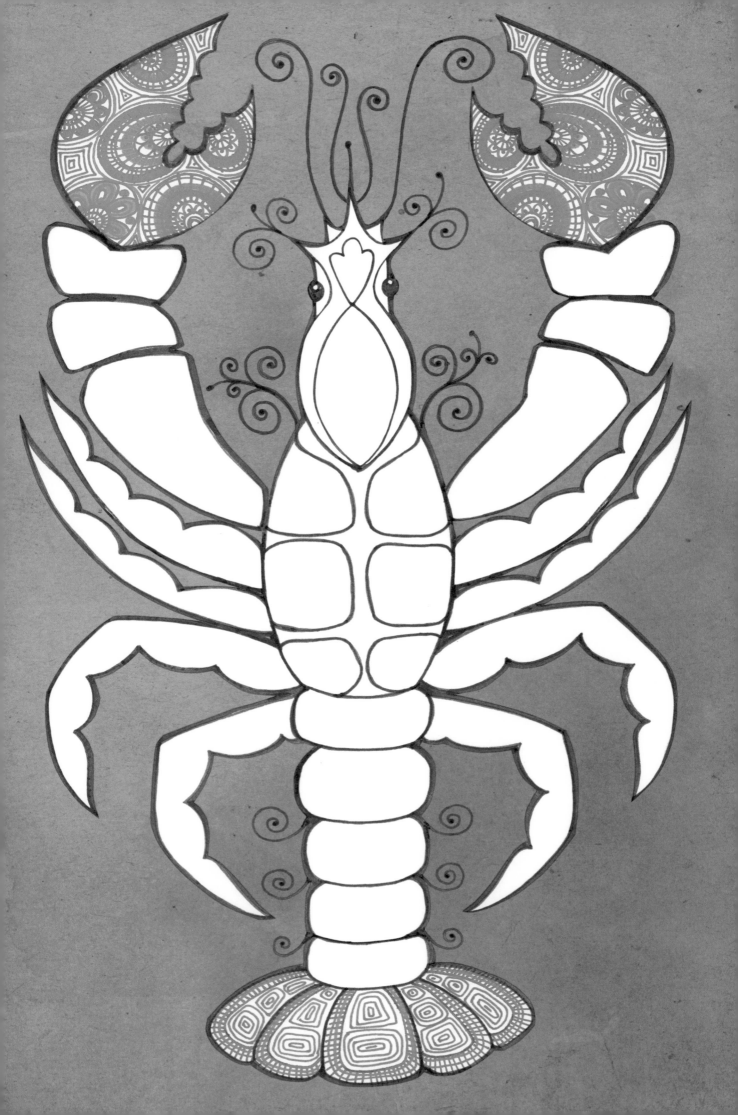

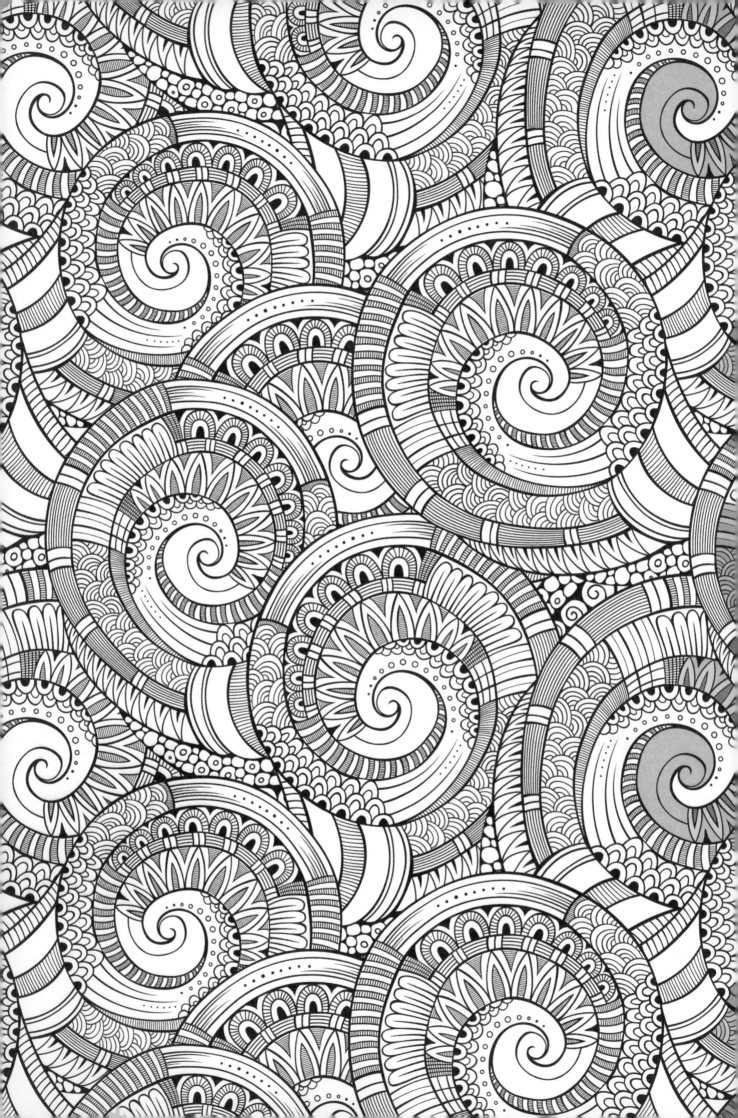

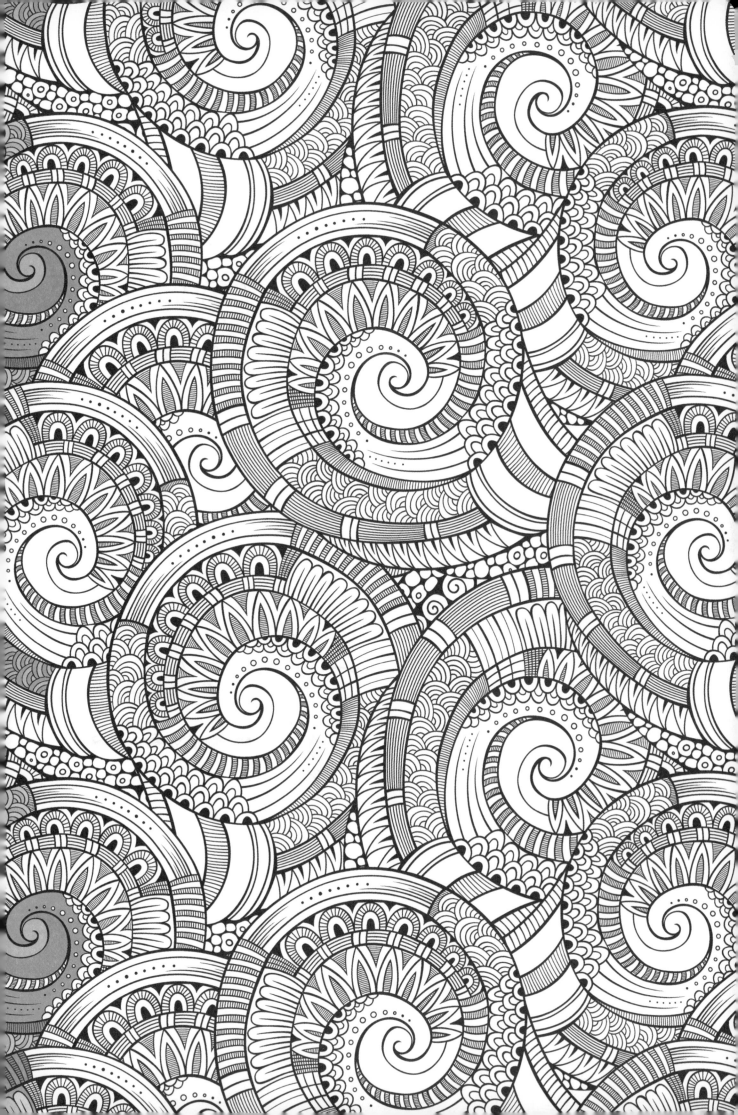

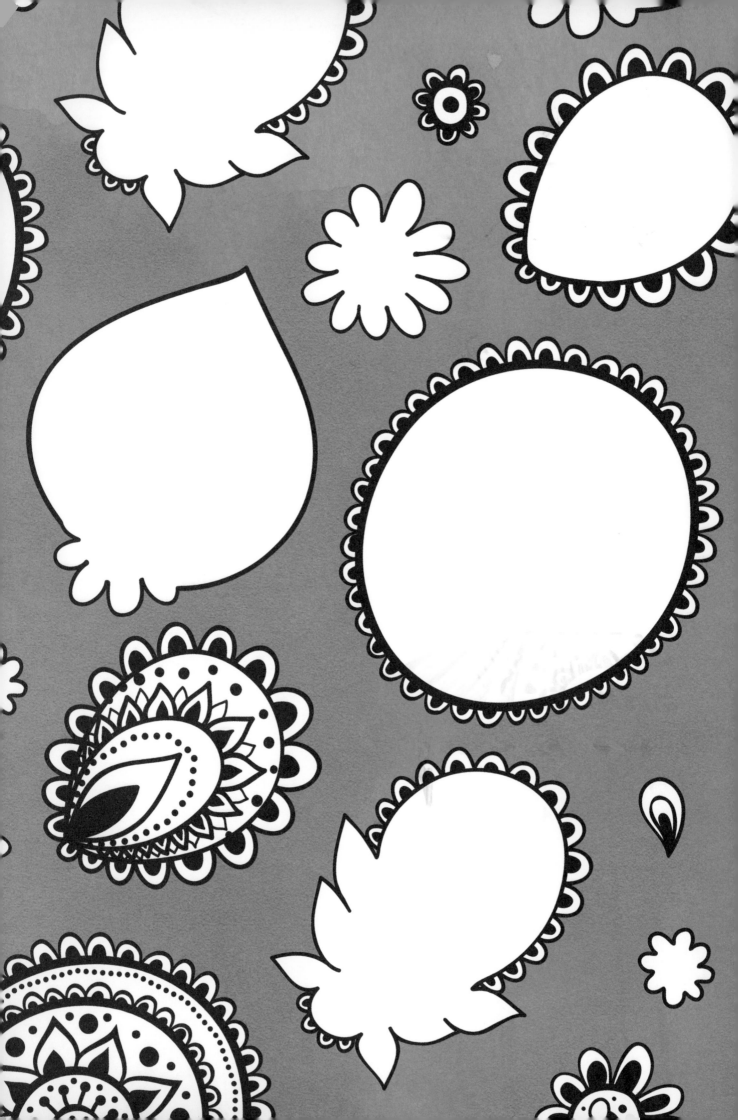

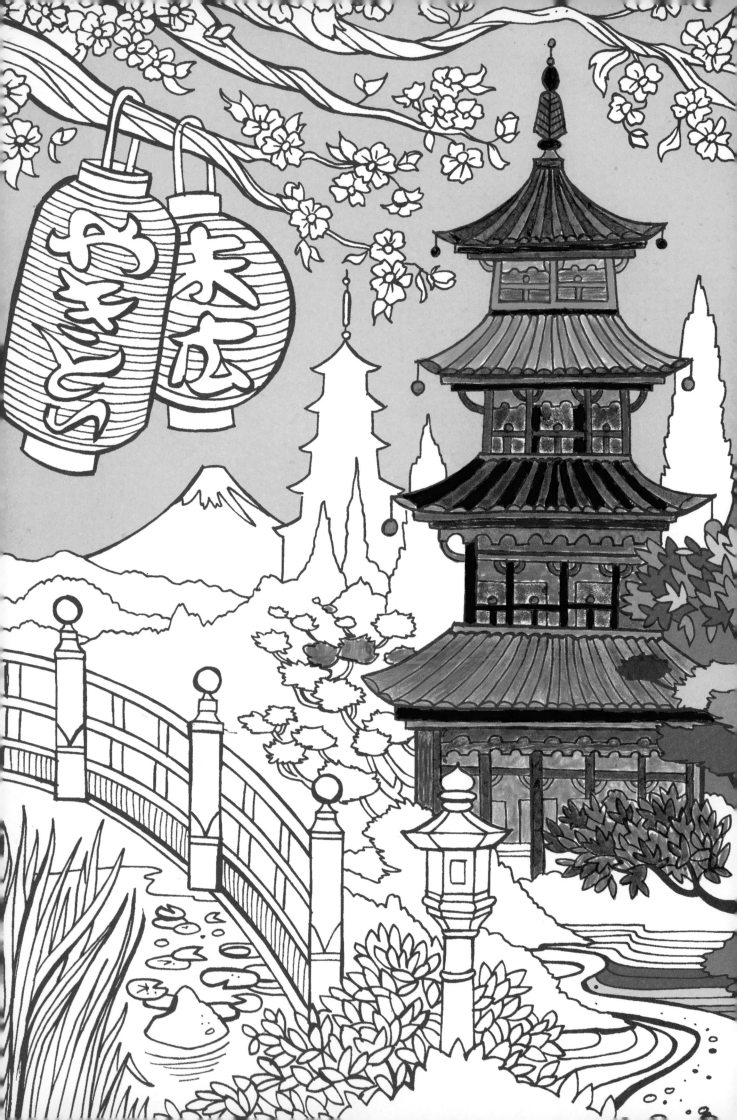

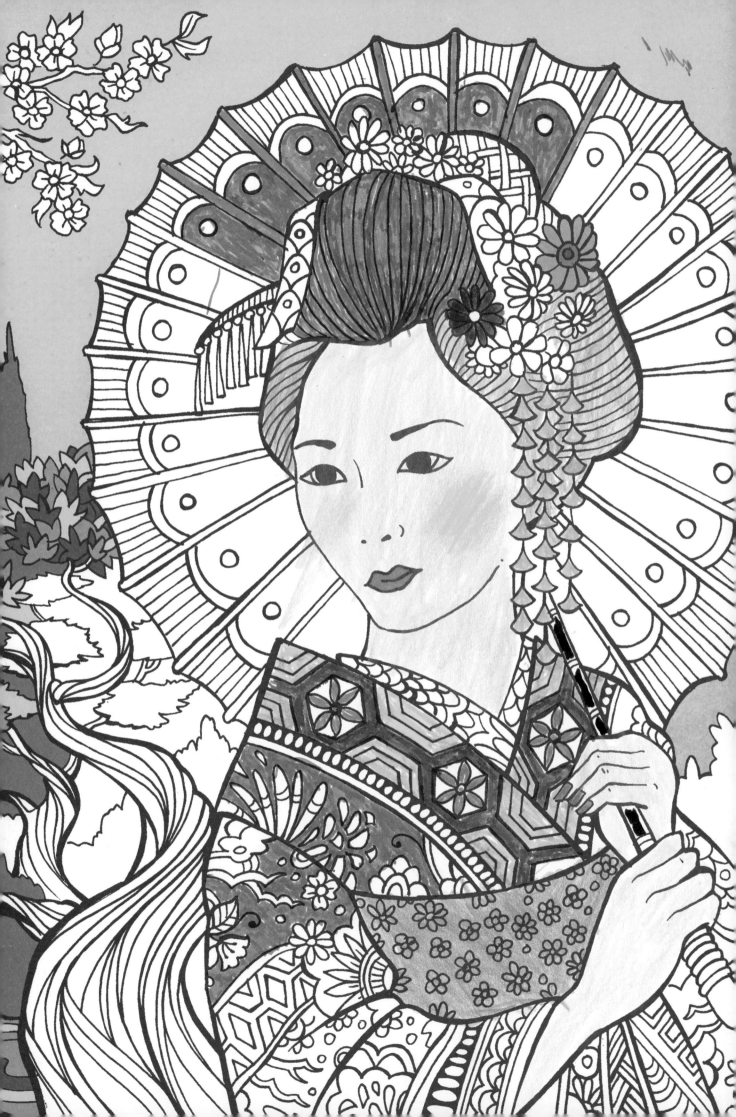

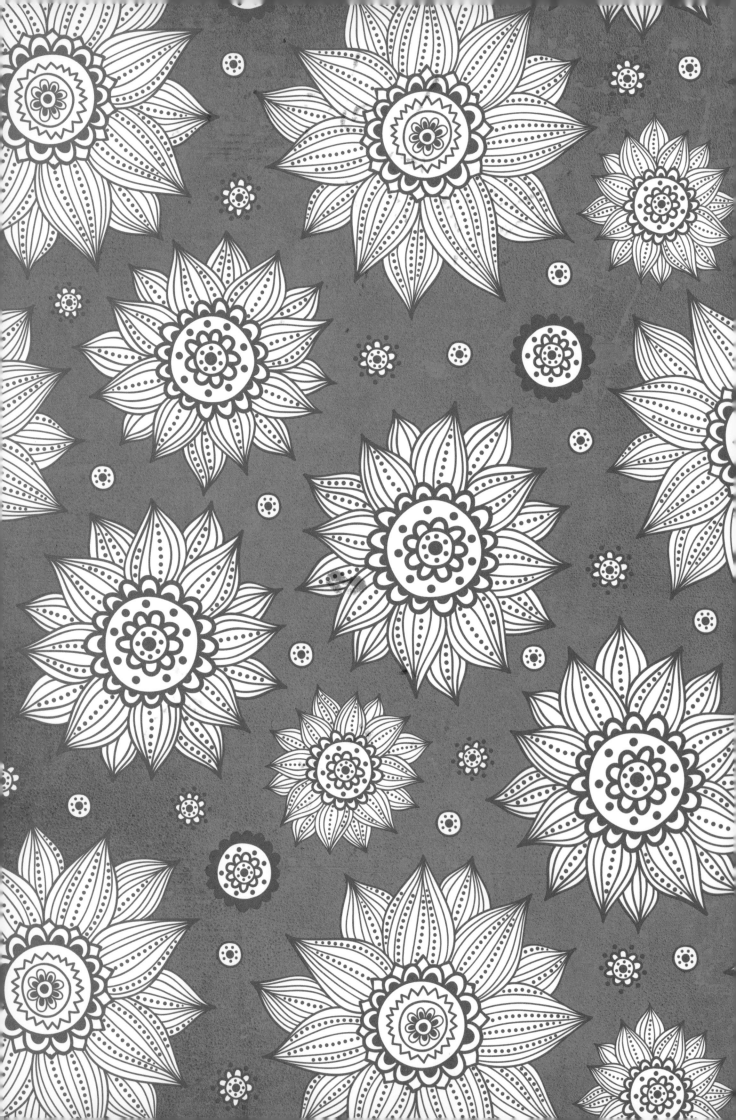

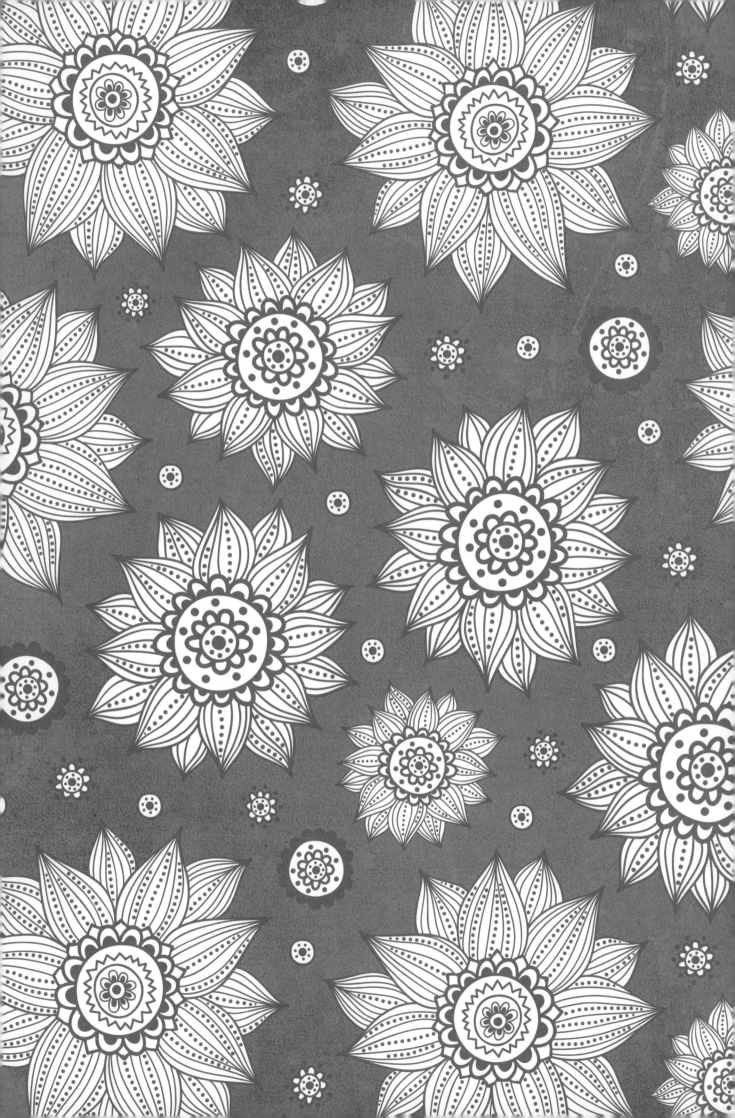

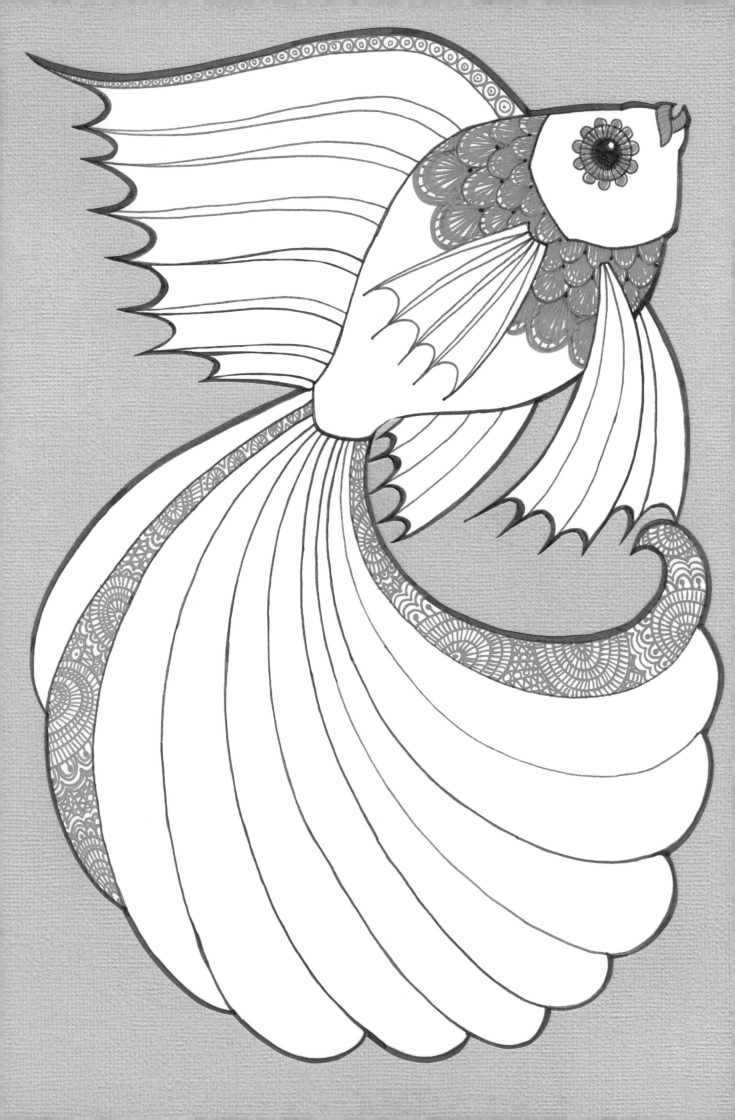